THE ARTIST IN NEW YORK

THE TEXAS PAN AMERICAN SERIES

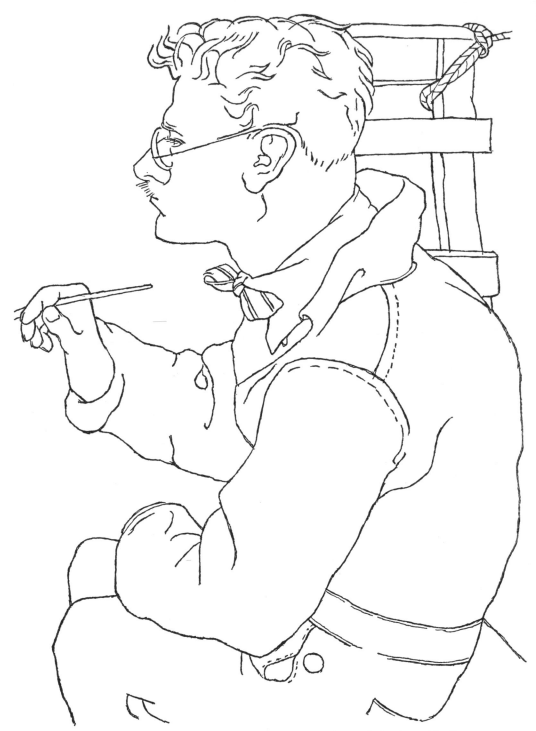

Orozco at work on his first mural. 1923. Drawn from life by Jean Charlot.

The Artist in New York

Letters to Jean Charlot and Unpublished Writings, 1925–1929

by José Clemente Orozco

Foreword and Notes by JEAN CHARLOT

Letters and Writings
Translated by Ruth L. C. Simms

UNIVERSITY OF TEXAS PRESS, AUSTIN AND LONDON

The Texas Pan American Series is published
with the assistance of a revolving publication
fund established by the Pan American Sulfur Company

Library of Congress Cataloging in Publication Data

Orozco, José Clemente, 1883–1949.
 The artist in New York: letters to Jean Charlot
and unpublished writings, 1925–1929.

 (The Texas pan American series)
 Includes bibliographical references.
 1. Orozco, José Clemente, 1883–1949. I. Charlot,
Jean, 1898– II. Title.
ND259.07C513 759.972 74-5235
ISBN 0-292-70309-0

CONTENTS

ILLUSTRATIONS

FOREWORD

"November 11, 1927. Colonia 9 P.M. Orozco leaves." An entry from my diary, this shorthand notation in telegraphic style opens the way for the letters that José Clemente Orozco wrote me from New York between December 1927 and October 1928.

His home was in Coyoacán, then a townlet in its own right rather than a suburb of Mexico City. I was the only person to see him off as he boarded the train for Laredo at the Colonia railway station, with a handbag for his only luggage.

Orozco was leaving Mexico an embittered man. His murals, painted on the walls of the Preparatoria School, had suffered substantial damage at the hands of students. In his plight Orozco had keenly felt the defection of fellow muralist Diego Rivera, whose friend Salvador Novo had rushed into print with an article that all but justified the vandals. In it Orozco was referred to as a student of Rivera, and an unworthy one at that.

Under Orozco's black mood there was cautious optimism. His devoted friend Anita Brenner, having preceded him to New York, prepared the way for his coming. In the October number of *The Arts*, she had published a farsighted evaluation of his work. As a result, there was talk of a one-man show in a New York art gallery.

An unusual feature of Orozco's letters is the great deal that he has to say about art. That one artist writing to another would

emphasize art as his subject seems normal enough to the American reader. Yet, within the context of the Mexico of those days, the fact remains exceptional. The patria Orozco was leaving behind had, even from the point of view of its artists, many cares more pressing than art. Confreres in Barcelona, Milan, or Paris could afford to sit at café tables and swap aesthetic theories, heatedly or gleefully, at leisure. For us the making of art meant fresco murals, climbing scaffolds each morning to do a journeyman's work. Painter and mason sat side by side on the same plank, each busy with the tools of his trade, and they received the same pay.

Of all the muralists, Orozco was the most taciturn. His left hand blown off at the wrist since childhood by a homemade firecracker, he could not fight in the Revolution. Nevertheless, he plunged with gusto into the thick of its affrays. In 1915 he followed the defeated president, Venustiano Carranza, in his retreat toward Veracruz, while in Mexico City, Carranza's formidable foes, Pancho Villa and Emiliano Zapata, held a victory parade and were photographed sharing the presidential chair.

Bearing no weapons, Orozco nevertheless focused his sights with the acuteness of any sharpshooter on scenes that needed neither emphasis nor distortion to stay etched. Friezes of telegraph poles with their crop of hanged men, seen from the troop train in motion. Early dawns, the return of night skirmishers, dead comrades slung over their saddleheads. Field hospitals on the move, leaving behind butchered arms, and legs, and torsos. The daily routine of a firing squad shooting peasant prisoners, white clad.

Not until 1926 did Orozco put down in a black-and-white set of drawings the cruel images that had festered in his heart for over a decade. Even so, the artist shied away from the fact that what once had been flesh, bone, and blood—mostly blood—now was art. When I suggested Goya's war etchings as a prototype for

the series, Orozco reproved me, in the soft subdued voice he used when in anger, "I am not Goya. Goya is only a painter."

In 1917, Orozco's first trip to the United States had turned into an orgy of cold and hunger and incomprehension. Most of his watercolors were destroyed at the border for their supposed lewdness. In San Francisco, to make a living, he was obliged to accept a full-time job tinting portrait photographs. When he returned to Mexico it was with a deep sense of defeat, followed by a period of sullen idleness.

In June 1923 the artist did emerge from this black mood. As the political winds shifted his way, he turned muralist. His plan was to decorate the patios and stairwells of the Preparatoria School, built in the 1750's to house the Jesuit University. In 1927 further political changes withered his grandiose scheme. His work and pay were stopped. When he left for the States, he was on leave from the one job he still held, a meagerly paid night professorship at the art school. Orozco truly was poor. A comrade-at-arms, Genaro Estrada, ascended to secretary of foreign relations, gave him the money needed for the projected trip. In New York, things having turned out slightly better than anticipated, Orozco dared let go of his professorship (letter 16).

The Mexican revolutionaries who survived had by 1927 achieved enough of their goals to wish for the status quo. Enjoying the style of upper dogs, yesterday's underdogs took a firm hold on the presidential chair. As firm a hold as had Don Porfirio Díaz, the aging dictator against whom they had rebelled when young.

Mexicans now found themselves burdened with two dictators whereas before there had only been one. General Calles having succeeded General Obregón as president of the Republic, Obregón made ready to succeed Calles. And so on ad infinitum. Both were men of action with the means to implement their dreams. Uninvited candidates to the presidency never lived long. General

Arnulfo Gómez faced a firing squad. General Francisco Serrano was shot, supposedly while trying to escape.

The country was in turmoil. Calles had closed churches and persecuted clerics. Rome countered by putting the whole of the nation under an interdict and excommunicating Calles. Religious and political opposition became so tightly meshed that, come the time for weighing causes for beatification, the finest of Italian hands will be needed to disentangle the two. Pious men thirsted for martyrdom and succeeded in, at least, dying.

In November 1927, President-elect Obregón escaped unhurt from an ineffectual bombing of his automobile. In March 1928, while seated at a rustic banquet given in his honor, he died riddled, so went the rumor, with more slugs than the assassin's pistol ever held.

Retaliation was swift. The Catholic opposition raised to the status of a holy icon a news photograph that showed a Jesuit, Father Miguel Agustín Pro Juárez, standing before a firing squad, seconds before his death, arms extended in emulation of the Crucified. I was close at hand and heard the successive volleys that killed Father Pro and his followers. Then I watched the mounted police charging into the crowd of faithful who fought for a blessed touch of the freshly sealed coffins.

In the countryside, deprived of mass and denied their devotional images, peasants rose in arms. Cristeros they were called, followers of Christ. An Emiliano Zapata had once led these same men to victory, but Zapata was dead. Their rustic revolution, or rather revulsion, was brave and brutal and doomed.

In March 1928, from Cuernavaca, my mother wrote: "The revolutionaries are encamped between Jiquilpan, Sahoya, and Zamora . . . They just looted a neighboring hacienda with such refined cruelties toward men and women both that it seems a throwback to the days of Attila. Battles are a daily occurrence at places I know so well, with many dead and wounded on both

sides. One sorrows at the thought that these poor peasants die only because they ask for the return of their priests . . ."

Baptized a Catholic, Orozco called himself a freethinker. In his political salad days, under the fatherly proddings of Gerardo Murillo, alias Dr. Atl, he had witnessed churches being sacked. He even had dipped his one hand deep enough into holy coffers and closets to bring home, when on revolutionary leave, a bag full of shiny things, liturgical vestments, patens, and candlesticks. His pious mother had hastened to return this sacred loot to the nearest church while her wayward son slept, for the first time in a long time, in a bed.

Be it as friend or foe, or both at once, throughout his life Orozco could never leave religion alone. He drew a comical "Christ the King," blond hair curly as the fleece of Mary's lamb, dressed in velvet and lace, crowned and beribboned, a ticket collector at the gates of Heaven. As they are ushered in, overfed bourgeois and their bejewelled females adjust each a halo. Contrariwise, the poor, the downtrodden, the hungry are shooed mercilessly into the outer darkness. Orozco's Marxist colleagues, thinking this funny, rejoiced.

Soon after, in 1926, to decorate the stairwell of the Preparatoria's main patio, Orozco chose episodes from the life of Saint Francis of Assisi and treated them with utmost respect. Best remembered is that of the saint embracing a leper, his bent cowled back echoing the architectural curve of the arch. This time the artist's Marxist friends did not laugh, puzzled by what amounted to a public act of faith.

Though he spoke slightingly of folk art, Orozco could not fail to commune, in village chapels, with the tragic mood of the many *bultos* and *santos*—statues carved out of a beam by the local carpenter, images daubed on zinc by house painters. Specifically, the Christs of Solitude were a match for the artist's blackest moods, hands tied and holding a reed for a scepter, crown of thorns set

askew, back scourged to the ribs, blood dribbling over dark Indian flesh. In New York on his rounds of Fifty-seventh Street's velvet-lined art galleries, Orozco came face to face with one of these Christs of Solitude he knew so well. This one was not the work of a Mexican peasant, however, but that of a modern French master, Georges Rouault (letter 30).

There is in his correspondence, once allowance is made for Orozco's tempestuous moods, the feeling of a belated adolescent awakening at meeting for the first time artists of the caliber of Seurat, Matisse, and Rouault. Though he was then in his mid-forties, Orozco can be said to have been in New York an innocent abroad.

During his earlier stay in the States, his care had been, not by choice, for things more rudimentary than aesthetic. In Mexico, it is true, there had been opportunities to learn about international modern art. A well-known American critic, Walter Pach, gave a series of illustrated lectures in Spanish at the Academy in the summer of 1922. I would not swear that Orozco, deeply suspicious of words meant to clarify the worth of images, attended each and every one of these interesting talks.

At least one of Orozco's colleagues was an expert in matters pertaining to the School of Paris, having known it from the inside. In a European exile that lasted eighteen years, Rivera had achieved an honorable rank among cubists, side by side with Gleizes, Metzinger, and Gino Severini. As may be gathered from his references to Rivera in his letters, Orozco felt no desire to sit at the feet of the younger master and receive lessons in modern art. In 1923 he wrote a series of aphorisms that made this feeling clear. I quote: "Some poems have very good spelling and a magnificent polish but are not worth a peanut. Some paintings boast the golden proportion and that famous cubist technique. They are not worth a peanut either."

Orozco's apparent lack of interest in what was going on in the

outer world was matched in full by the lack of interest with which the outer world looked at his art. In 1926, I took a French cultural attaché to the Preparatoria School to show him the frescoes that the artist had completed on the third floor of the main patio, revolutionary scenes in an admirable palette of grays, ultramarine blue, and rose earth. On our way to the school, my companion freely enthused about Marcel Proust, whose *Albertine* and *Le temps disparu* were published that year. He politely paused before the frescoes—*Adieu to the Mother, The Idle Earth, The Grave Digger, The Rear Guard*—then pontified gently, "I wonder what Paris would have to say about that."

The fact that Orozco arrived in New York lacking the art vocabulary that anyone can memorize by subscribing to art magazines did not mean that he was the kind of instinctive doer who prides himself on being a know-nothing. For the artist to be born a Mexican implied mental complexities that did not admit of easy solutions.

In 1803, having stepped over the Coatlicue, the Aztec monolith that lay half buried in a patio of the university, and been shown a collection of classical casts, a royal gift from Spain to the school of art, Baron Alexander von Humboldt wrote: "The remains of Mexican sculptures, those colossal statues of basaltes and porphyries which are covered with Aztec hieroglyphs . . . ought to be collected together in the edifice of the Academy . . . It would be curious to see these monuments of the first cultivation of our species, the work of a semi-barbarian people . . . placed beside the beautiful forms produced under the sky of Greece and Italy." Loitering through Mexico City, Orozco and I unknowingly fulfilled Baron von Humboldt's wish. In those days, the archaeological collections, including the Coatlicue, were kept in the old hospitable Casa de Moneda, which had once been the Royal Mint. Ancient sculptures lay scattered along its patio and halls with little more dignity than family discards in an attic.

From the Mint it was but a short walk to another beautiful Colonial building, that of the art school, chartered in 1785 as the Royal Academy of San Carlos in New Spain. The very same plaster casts that Humboldt had seen—the Apollo Belvedere, the Laocoon, others—were still there, dust encrusted, cracked somewhat and flyspecked, after over a century of uncare. The galleries of paintings were relatively new, having been installed in midnineteenth century. It is before these works that young Orozco had become conscious of his genius. From Spain, Zurbarán's *Pilgrims of Emmaus*. From France, Ingres's *John the Baptist as a Child*. Even more direct were the lessons to be gathered from native Colonial masters—the Echaves, José Juárez, Villalpando—men who had solved as best they could the dilemma that also was Orozco's, that of being born Mexican, with a heart split between Huitzilopochtli and Christ.

Critics intent on listing Orozco's early stylistic sources should not stop at the three just mentioned: pre-Hispanic, Classical, Colonial. There was a fourth that we rarely mentioned in the presence of the artist, for he considered it somewhat disreputable. In a world of constantly shifting politics, Orozco had learned the hard way not to count for long on a government job. For many years his only regular source of income, small though it was, came from drawing cartoons, comical or political, for newspapers and weeklies. Of itself the solution was not original. In Paris, contemporaries of Orozco had done the same. On occasion, Jacques Villon and Juan Gris collaborated with weeklies—*L'assiette au beurre*, *Le sourire*—that skirted the borderlines of pornography. Both masters having achieved in their maturity a style based on geometric aloofness, critics feel justified in bypassing the cartoons.

With Orozco it is otherwise. There is no true point of cleavage between his newspaper juvenilia and his mature works. Mexico has a strong tradition of political cartooning. Throughout the nineteenth century, opposition weeklies featured caricatures

drawn with the lithographic know-how of a Daumier. In the 1860's, Constantino Escalante personified the patria as an Indian maiden lightly clad, dark skinned, and plumed, laughing at the blond emperor, a puppet propped up by French Zouaves in baggy pantaloons. In the 1870's, Villasana laughed away the anticlerical policies of Benito Juárez by coifing his political disciples with mortarboards embellished with white plumes, the insignia of a doctor of theology, earned by these freethinkers when they were students of the Jesuits.

Weeklies and their lithographic cartoons reached the high-brows and the middle-brows. The low-brows preferred the penny-sheets—selling indeed for a penny—noisily peddled by shoeless street urchins. The tales they told were horrendous, printed on cheap paper dyed sulfur yellow, magenta, or lettuce green and illustrated with correspondingly bold images, cut in wood or metal. The master of this rough tough style remains Guadalupe Posada, who carved his blocks at the turn of this century in plain sight of the passersby, in an open stall only a street away from the art school. Revolts and revolutions proved to be a boon to his trade. One day he would portray a political hero making his triumphal entry into the capital. The next day the man was a *calavera*, a skull, which Posada, to make the point keener, stuffed with maggots.

Orozco's earliest political cartoons date from 1911. They blend the know-how of the lithographs with the toughness of the low-brow line cuts. In France, Honoré Daumier, transforming King Louis-Philippe into a pear, did so gently, with velvet paws. In Mexico, Orozco bared his claws for the kill when he portrayed President Madero—savior of his country and martyr to be—in the semblance of a chickpea. The artist drew his last cartoons in the middle twenties. Published in *El Machete*, organ of the Syndicate of Painters and Sculptors of which he was a member, they were unsigned for obvious reasons. A muralist companion, Xavier

Guerrero, was fired from his government job when suspected of being the author of the most bilious among these political comments: President Obregón embracing a Catholic bishop.

Orozco's newspaper cartoons always were more epic and tragic than comic. Their style veered effortlessly to the monumental when the artist switched from paper to wall and from pen and ink to fresco. In 1925, I became art editor of *Mexican Folkways*, the English-language monthly launched by Frances Toor. In it I featured proudly one of Orozco's line cuts drawn in his lighter vein. The first two letters of the series underline to what extent we disagreed on the worth of his caricatures.

In many a letter (nos. 23, 27, 28, 30 to 35) Orozco stresses his pressing need for photographs of his murals, in the hope that American architects would give him the walls he had been denied at home. Tina Modotti and I attempted the task. A beauteous Italian American, Tina had come to Mexico in 1923 as assistant to Edward Weston. She was in her own right a sensitive artist, and her photographs of whitewashed adobe walls will be rediscovered in time as precursors of the minimalists. She was a selfless person. Having joined the Communist party, she gently complained that comrades, knowing her to be by trade a photographer, expected their family portraits free of charge. In her help to artists, she was untiring.

Easy to sketch from memory in his letters, Orozco's photographic directives posed substantial problems when weighed *in situ*. Tina's paraphernalia was old-fashioned even for that day, and it took much ingenuity to fit her bulky box camera and tripod along the staircases and under the low arches of the Colonial building. For days we worked throughout the daylight hours, stopping only for a beer and sandwich brought by Tina's friend Julio Antonio Mella. Young and handsome, Julio was a Cuban political refugee studying law at the university. I saw Mella for the last time in October of 1928. The following January, he was

gunned down in a downtown street by *pistoleros,* presumably in the pay of the Cuban Embassy.

The funeral of the still-warm martyr of the left became an occasion for violent street demonstrations. A news photograph shows a giant red banner being carried over a sea of closed fists, with Diego Rivera heading the parade, as its self-appointed grand marshal. As to the mural photographs, some we mailed and others I took to Orozco in New York. Most were reproduced in the monograph *José Clemente Orozco* published in 1932 by Delphic Studios.

From 1926 to 1929, the years covered by this correspondence, I left Mexico City every January for Chichén Itzá, Yucatán, staying there until June. As artist on the archaeological staff of Dr. Sylvanus G. Morley, I copied bas-reliefs and murals as they were brought to light, before their polychromies began to fade. Mayan art was truly meant for the community at large. It was exciting to thus compare frescoes done five centuries ago with those we painted in Mexico City with a similar aim.

The archaeological season of 1928 proved especially rewarding. Within the pyramidal platform of the Temple of the Warriors was uncovered a still-older temple, buried as obsolete by the Indian builders. From under the floor of its altar was dug a cylindrical box meant as its cornerstone. In it was a pectoral disk, a turquoise mosaic of entwined plumed serpents, reproduced as the frontispiece of our published report.

Live Mayans are made of a stuff as exciting as that of their ancestors. In letter 22, Orozco quotes my mention of a tiger hunt, but only as a pretext to develop a parable on the theme of human unkindness. For the Mayan the hunt was fact, not parable. He sought the jaguar in bush country, with a one-shot gun and a dog, with a miner's lamp lighted on the rim of his hat to lure the prey. The shot had to be synchronized with the beast's pounce, and often the hunter became the prey. One early dawn a man, his

arm half bitten off, nevertheless reached our hacienda lugging
the dead animal on his back.

Thus, from January to June, the bulk of Orozco's letters reached
me in Chichén Itzá. His tales of an America shaped after the thin-
lipped silences of a Coolidge opened for me vistas of a pictur-
esqueness at least equal to that of our Mayan pyramids bathed in
moonlight.

"September 22, 1928. See Tina: photos. Departure 9 P.M."
Written on the train, this entry from my diary marks the day that
mother and I left Mexico for New York. My last errand had been
to add the latest Orozco photographs to the charcoal drawings
and pen-and-ink revolutionary themes collected previously from
his studio in Coyoacán. All were artfully hidden under samples of
my milder brand of art as I remembered with trepidation how, in
1917, the U.S. Customs had destroyed sixty of Orozco's water-
colors.

We reached New York on the twenty-seventh at noon. Anita
Brenner and Orozco were at the railway station to greet us. It
was my turn to be an innocent abroad. Orozco did his best to help
us make sense of this new world. We marveled at the sight of an
automat, how the food on display could be ours by plugging
nickels in a slot. We went sightseeing down the length of Fifth
Avenue, seated on the top of an open two-decker bus, craning
our necks.

Orozco's studio apartment on West Twenty-second Street was
a one-room affair, lacking even the small recess that landlords
call a kitchenette. The furniture was spartan—a bed, a drawing-
board with ruler, compass, and eraser at the ready. On a make-
shift easel was a tempera rendering of a naked Greek athlete,
brick red on a black background. Over the chimney hung a faded
laurel wreath. Queried as to its meaning, Orozco mumbled in-
distinctly. Only later did I learn that his Delphic friends, in a
ceremony *à la Grecque*, had crowned him with these laurels as

they bestowed upon him a new name, Panselenos the Heroic. The naked Greek athlete and the faded laurel crown provided my first intimation of how involved Orozco was with these most unusual friends who, regardless of their strong idiosyncracies, were to accomplish so much so selflessly for the artist.

Loitering together in the streets of New York was not as rewarding as it had been in Mexico. Orozco remained fascinated by the electric sign that belted the Times Square building with a running review of the news. I meant to move on but he would say softly, "Wait, there may be some news about Mexico after a while."

Once, with great expectations, we paid a call on the president of the American Society of Mural Painters. His giant studio was as fussy as a drawing room. Its furniture ran the stylistic gamut of all the Louis that ever graced a French throne. After a while the lady of the house joined us, adding a whiff of patchouli that rounded out the decor. As Orozco was getting impatient, I asked, "Could we see the murals?" With a flip of his wrist our host pointed to the large screens that surrounded us and that we had thought bare. They were painted in imperceptible gradations of grays, with statues and fountains, ponds and swans, all set in a fog-clogged Versailles.

Orozco took it upon himself to be my mentor. Some of his advice was naïve in the extreme: "Juanito, little John, here it is better to say we are Spanish, not Mexican. Otherwise they say, 'Ha! You are a student of Diego Rivera.'" Some of his advice was extremely shrewd: "Juanito, little John, if you have to sleep with an American girl, choose wisely. Otherwise she may publish a book about it!"

I was invited to the Ashram, the *cénacle* presided over by Madame Sikelianos, née Cortland Palmer. In a vast room dimly lit, an abundance of carpets and sofas put at ease the many Indian guests. Over it all hovered the shade of Raymond Duncan, first

among the neo-Greeks. Shoes were out and sandals in. Though much was made of him, Orozco remained odd man in this choice stable of poets and mystics. Top man was Claude Bragdon, who, at the drop of a hat, seemed ready to ascend into a fourth dimension. His counterpart, or rather his counterweight, Madame Sarojini Naidu, plumped down her round body wreathed in seven veils so solidly that she became a cushion among cushions.

I missed a star guest, a Hindu guru who never said a word, in any language whatsoever, but allowed faithful female followers to nestle under his long thick beard for a spot of transcendental meditation. I was present, however, when a delegation of popes from the Greek Orthodox church, imposing in their ecclesiastical vestments, astonished Madame Sikelianos by offering her, in its enameled reliquary, a fragment of the True Cross, in thanks for what she had done for Greece. Either the popes were misinformed or very shrewd. The Greece that the Ashram revered was, up to then, more B.C. than A.D.

This period in my life lasted three months. Mother and I, shopping for a rent within our very small means, chose unwisely. Our attic on Union Square had no heating system of its own, only what hot air could reach us from the heated apartment below. Mother had lived most of 1928 in the warmth of Cuernavaca. The hideous New York winter killed her. She died of pneumonia in January 1929.

It was my archaeologist friends, Earl and Ann Morris, who took care of me after that. We three left for Washington to ready our field report for the Carnegie Institution. Orozco's last letter reached me there. It was written just before he received great mural commissions: Pomona, the New School for Social Research in New York, Dartmouth. The international fame that his Ashram friends had wished for and worked for was upon him, never to let go.

The Letters

§ 1 §

10 Nov. 25

Charlot,

I have just received the latest issue of *Mexican Folkways* and I was not at all pleased to see my name given as author of the drawing that Miss Toor reproduced without my permission.[1] If I don't sign those lousy things it is because I don't want to be identified with them and I think that my wishes should be respected. In the same magazine there is also a certain article that, like all the others of the same kind, is nothing but a string of insults and abuse intended for a definite very special purpose and with excessively transparent allusions.

For both reasons I ask you to tell Miss Toor *to kindly abstain, in the future,* from using my name and my works in her publication.

Thanking you in advance,

J. C. OROZCO

[1] Frances Toor, an American living in Mexico, published *Mexican Folkways*, a somewhat irregular monthly. I was art editor from its beginnings in 1925 until Diego Rivera replaced me after the fifth issue. Each of these early numbers featured a supplement, a tipped-in center spread. For *Mexican Folkways* no. 2, I borrowed from the weekly *A.B.C.* a metal cut of one of Orozco's pen-and-ink drawings, *The Wake*, rated by him as no more than a caricature. In the 1932 monograph published by Delphic Studios, Orozco chose to reproduce this same drawing, having changed his mind about its worth.

§ 2 §

My dear Charlot:

You are right, the matter of the drawing is not important, what really irks me is that my friends should deliberately become the pawns of that man's intrigues. Didn't you notice that this article is a vile plagiarism of the one you wrote about Posada?[2] Don't be so naïve, Charlot.

The day before yesterday I went to see Miss Brenner and Miss Barbara.[3] I was very sorry about what happened to them and I plan to visit them again soon.

Your sincere friend,

J. C. OROZCO

§ 3 §

N.Y. 21 Dec./27

Brother Jean:

This is the first chance I've had to write since I arrived on Fri-

2 Diego Rivera, "that man," was often alluded to by Orozco though rarely mentioned by name. In August of that year, 1925, I wrote for the weekly *Revista de Revistas* "Guadalupe Posada: Printmaker to the Mexican People." Up to then, Posada had been forgotten as a personality, lost in the crowd of anonymous folk engravers. Rivera published soon after mine his own appreciation. In the first chapter of his autobiography, Orozco writes movingly of his visits to Posada's workshop, situated a block away from the art school where he was a student.

3 Anita Brenner was, at the time, writing the notes on Mexican art published as *Idols behind Altars* (New York: Harcourt, Brace and Co., 1929). She also was instrumental in having Orozco start the ink-and-wash series of revolutionary subjects, usually dated from 1916 but begun no earlier than 1927, shortly before the artist left for New York. See my "Orozco's Stylistic Evolution," *College Art Journal* (Winter 1949–1950), republished in *An Artist on Art* (Honolulu: University of Hawaii Press, 1972). Barbara is Anita Brenner's sister.

day night, very tired and during a spell of terribly cold weather. I saw Anita on Saturday, she greeted me with a "How awful!" because she says she wrote me not to come until April, which was when the exhibition of 12 of my drawings was to be held, and although she doesn't actually say so, I understand that it's all off now.[4]

I had to come in as an immigrant, that is, by making statements under oath and paying 10 dollars more, or 18 in all. They lectured me because I stayed for 2 years the last time, instead of 6 months, but I told them it was on account of the Revolution. This time I can live here for as long as I wish. The material life is *very expensive*, more so than before. And I'm not the only one who says this, everyone agrees. To give you a better idea, I'll tell you that what you pay in Mexico in pesos silver, you pay here in dollars plus about 10 percent. It's true that some things are very cheap, clothes, for example, but that is misleading because they are either things you don't need or else they're of poor quality. Anita and Lucy have a little apartment with two bedrooms, a small living room, and kitchen, and it costs them 78 dollars in one of the cheapest neighborhoods.[5]

Yesterday I saw two exhibitions, Picasso and Renoir. Drawings by the former: figures apparently copied from Greek vases in museums. Just two or three lines. Much repetition. Ink drawings. A very skilled hand. Pencil drawings with "much volume." I tried desperately to be enthusiastic but couldn't. You and I have drawings a hundred times better. A pastel landscape that as W. Pach says is exactly like Derain's.[6] Renoir impressed me very much, I

[4] On a visit to Mexico, Ernestine Evans had told Anita Brenner that she would arrange such a show, to take place at the Whitney Club.

[5] Lucy Knox, a southerner, already had roomed with Anita in Mexico City. Their New York address was 357 West Twenty-third Street.

[6] Walter Pach, an eminent art critic, who played a decisive part in the Armory Show of 1913 and was one of the founders of the Society of Independents of New York. I have already mentioned in the Foreword his lec-

liked him *exceptionally* well. I spent an hour and a half looking
at five or six little pictures. The rest are not as good, they must be
studies or early works. In the evening I visited W. Pach. Very
pleasant. Magnificent studio. He gives lectures at the Metropoli-
tan Museum. He does NOT take me very seriously as a painter. A
passionate admirer of Picasso. He didn't like what I said. He
showed me his own works and asked my opinion of them. He did
NOT like my frankness. His wife as a *china poblana*! /Wonderful
picture/.* He took me to visit the /independents/. A nude model
for 1 dollar an hour. In his house he has some very good pictures:
a head by Derain—very fine!—, lithographs by Cézanne, Signo-
relli, etc. There wasn't time to see them all.

Anita says that Mrs. Paine must be there by now.[7] Please see
what would be good to give her from my things there. From the
things my brother-in-law hasn't sold and what I have in Coyoacán.
I'll leave it up to you. If you don't find anything suitable, then
nothing. I'm sorry to bother you about this. If there is anything I
can do for you here, I am at your service.

I'll save the news for later. A very affectionate greeting to the
Señora your mother.

 J. C. OROZCO

Write me in care of Anita's address because I'm not settled yet.

tures on modern art given in Mexico City. For the monthly *México Moderno*,
October 1922, Pach wrote the first respectful estimate of Orozco's premural
work. Published in 1925, his *Masters of Modern Art* (New York: Viking
Press) includes a first attempt to evaluate Mexican muralism as understood
in an international context.

* Diagonals set off English words used by Orozco.—Trans.

[7] Frances Flynn Paine worked actively and selflessly to introduce Mexican
art to the United States. She took with her, when she returned to New
York, paintings by Orozco as well as mine. From my diary, 1927: "Decem-
ber 19. Frances Paine has arrived [in Mexico City]. December 26. At
Orozco's [in Coyoacán]. See his mamma and his wife. Return with some of
his paintings [for the New York show]."

§ 4 §

N.Y. 3 January 28

Very dear Juan:

I haven't heard from you and I suppose it's because you're so busy with Mrs. Paine and your trip to Chichén.[8] I hope my letter asking you to kindly see what could be given to that lady from my things there arrived in time.

I can tell you that I am not exactly enthusiastic about the idea of the show at the Art Center, but just so they won't say that I am interfering with their good intentions I don't say a word.

The only thing I've been doing is getting settled and wandering through the city, visiting galleries and museums and defending myself from the cold, which is very unpleasant for me after Mexico.

As for painting, I've seen many things: an exhibition of works by Picasso, Matisse, and Derain mixed with small pictures by /American painters/: the poor things! They delude themselves by thinking that if they mix their works with those of the masters it will mean a great deal to them. Picasso's pictures have nothing new, they are identical to the reproductions. Derain's, in that show (which is privately owned and on loan to N.Y. University),[9] are not very important, but one of the Matisses was something very new to me: extraordinary color and so fine, so fine that it is almost like India paper and colored silk, without losing its plastic quality. The show at the Valentine Gallery, the catalog of which

[8] Orozco's letter, dated January 3, reached me in Yucatán. From my diary: "January 7. Leave [Mexico City] 7:05, Buenavista Station. Arrive Veracruz 7:14. January 10. Arrive Dzitas ca. 10 A.M." Dzitas was the last inhabited spot before starting for the ruins.

[9] The Museum of Living Art, Albert S. Gallatin's private collection, was on loan to the university since 1927. It was strong in early cubist paintings, including Picasso's *Three Musicians* and his self-portrait of 1906. My own favorite was Ozenfant's still life, *A Glass of Water*.

I am enclosing, is *vastly better*, divided equally between Matisse and Derain; this is the first time I have seen modern art, art of the present day, without feeling nostalgia for ancient art. Pure painting, without any subterfuges. Grace. Naturalness. Joy. It is a great pleasure to see these pictures, and it makes one feel happy and contented for the rest of the day. Derain's are torsos of women, fleshy and profound. Matisse is color and light, freshness, serenity. These painters are people who live in gardens and meet their ladies for five o'clock tea, they frequent the salons and are acquainted with good society, good drinking, and good beds. We are the revolutionaries, the accursed ones, the starvelings.

Decidedly, here in N.Y., French art means the cream of the cream, it is the ideal, the top, what is most prestigious, the model; to praise something one compares it to the French. That is what is most exquisite.

Perhaps one day we Mexicans may come to have some influence, but it will be in another direction. There is nothing "exquisite" about us; /"Do you know what I mean?"/

The girls went to Boston supposedly to a convention of anthropo-phagi[10] and came back raving about the museums in that city. They make me want to go there.

Why don't you write?

Tell your mother I wish her, and you, too, a happy New Year.

J. C. OROZCO

316 W. 23d St.

Poor /fat man/![11] Just *inter nos*: I think he's making a fool of himself.

[10] A playful variant for anthropologists. Anita was preparing her doctoral thesis at Columbia University under famed anthropologist Dr. Franz Boas, who that same year (1928) published his *Primitive Art*.

[11] Diego Rivera, who was not thin.

§ 5 §

4 Jan. 28

Very dear Jean:

I received your letter today. Try to send as many of your works as possible. I wish I had mine here and the only reason I didn't bring them was for fear of having them taken away from me.[12]

Everything you did was perfect. If there is any way to send the drawings you mention, do so. Could you send them with Mrs. Paine? That would be the best.

The only thing I am doing now is "getting adjusted." How happy I would be if you were here! There are many interesting things to see, both American and imported. With their money they are bringing Europe over here, stone by stone. Any day now they will set up the Eiffel Tower in Central Park, next to the obelisk. You should see the machines for excavating rock and burying the iron that will support a skyscraper, and 10 minutes away you can see a collection of Grecos and 3,500-year-old Egyptian tombs!

I have just seen: a whole collection of 18th-century art: furniture, tapestries, architectural pieces, Watteau, Fragonard, Boucher, Pater, etc.

The Hispanic Museum: a big room decorated with large mural paintings (?) by Sorolla, the tiresome fool![13] That fellow confused painting with the Flamenco *cante jondo*—olé!—and only about 10 yards away from El Greco, Goya, and Velázquez.

[12] A reference to the artist's first trip to the United States, when customs officers destroyed sixty of his watercolors as lewd. In 1927, Anita Brenner had volunteered to bring some of the revolutionary drawings to New York before Orozco's arrival. Mrs. Paine brought others, and I later took with me the rest of the revolutionary drawings and also some mural studies.

[13] Soon after I arrived in New York, Orozco took me to see the Hispanic Museum. He acted most solicitously as my guide but declined forcefully to enter the big octagonal hall in which Sorolla's "murals" were showily displayed.

More paintings by Picasso, he disconcerts, disquiets, wounds, impassions, repels, and then attracts vigorously. You do not forget him. Nor can you forget Renoir. If only I had one of those little canvases!

You have no idea how funny the /American painters/ are, there are thousands of them. In the Metropolitan Museum there are rooms and rooms, but the curious thing is this: among the /American/ paintings you suddenly find a Cézanne, then more /Americans/, then another Cézanne and then a Pissarro and then Claude Monet, and in other exhibitions they are mixed in with Picasso and Dufy and other French artists. I don't know why they do this because only a blind man can confuse the one with the other. They have only been able to "catch" or understand (and that only incompletely) very little or almost nothing of the French "theme," that is to say, the /"literature"/ part or what they think is the /"literature"/ of European painting. I assure you that the /American painters/ are a real tragedy. A tragedy that has an enormous lump of gold—a mountain of gold!—tied around its neck. It will collapse and no one will be able to stop it. The real American artists are the ones who make the machines: you have to take off your hat to them . . .

Be sure to write.

<div align="right">CLEMENTE</div>

<div align="center">§ 6 §</div>

<div align="right">N.Y. 28 Jan. 28</div>

Jean:

Just wanted to ask if I can write you in Yucatán and tell you some very interesting things.

<div align="right">CLEMENTE
316 W. 23d St.</div>

§ 7 §

New York, 22 February 1928

Mrs. A. Charlot Goupil
México

Very esteemed Madam:

I was very happy to receive your letter. When Juan's pictures arrive I shall take very good care of them, please tell me who will be bringing them or where I am to pick them up.

With regard to the exhibition at the Art Center, it was a total failure.[14] This is one of the worst galleries, it is very poorly organized, the pictures that were most visible and in the best places were those by Pacheco, Ruiz, and Montenegro.[15] The serious art journals and the professional critics didn't even mention it and the /magazines/ and newspapers only joked and made fun of it, there were some really disgraceful comments. The very few people who visited the exhibition just said, /"I am disappointed,"/ because it had been rumored that this was going to be a great exhibition of Mexican painting, representative of the country and sponsored by the Mexican government, and the only things that anyone could see were the pictures by Pacheco, Ruiz, and the large number of *aficionados*, or amateurs who are regarded as "great artists." The comments that were heard in the hall were enough to make one

[14] It opened January 19, at 65 East Fifty-sixth Street, "under the auspices of the Mexican Government."

[15] Máximo Pacheco, an Indian boy still in his teens, patiently drew rustic themes that blended innate sophistication and folk mannerisms. Antonio Ruiz, a professor at the University of Mexico, specialized in tiny easel paintings, crammed with good-humored notations of Mexican rural scenes. Roberto Montenegro had received in 1920 the first monumental government commission: two stained-glass windows for the former church of San Pedro y Pablo, now the Hemeroteca Nacional. For Orozco, Montenegro's cardinal sin may have been that he chose for his theme *chinas* and *charros* dancing the popular *jarabe tapatío* (see p. 90).

blush and the people laughed and howled. There were also many of Hidalgo's little wax monkeys and dressed fleas.[16] It seems that only one picture was sold and it was one of Juan's.[17]

With regard to the matter of the "potentate" Rivera, it's more serious here than in Mexico: he already has incredible publicity, and the idea is now firmly established that he is the great creator of everything and the others are only his disciples. Whenever I am introduced and they hear "painter from Mexico," they say: "Oh, then you know the great Rivera! /Don't you?"/ He had an exhibition here at a very small gallery with a multitude of drawings and paintings from all periods and all "schools" and, despite the fact that it was a really ridiculous /show,/ it was praised highly, although not as highly as he wished.

I don't see Anita any more—I have broken off all relations with her—and as to "Friends," they do not exist for me. Here in New York there is only self-interest and deception and bad faith. I am completely alone, relying on my own forces, which happily are still considerable. A foreign country is where one gets to know people best. Here my "friends" have scorned and humiliated me.

This is a very hard struggle. As far as painting is concerned, it

[16] Luis Hidalgo's miniature wax figurines, dressed as dolls in a variety of materials, were heirs to a form of folk art dating at least from the eighteenth century. "Wax monkeys" is a figure of speech but "dressed fleas" is not. Though Hidalgo did not practice the art, mummified fleas clothed as Mexican peasants were, especially in the nineteenth century, a much sought after form of folk art.

[17] *Dance of the Malinches*, reproduced on the cover of the catalogue under the title of "Fiesta," was bought by Frank Crowninshield, editor of the modish monthly, *Vanity Fair*. Orozco did not exaggerate the facts. In a letter dated March 3, my mother writes, "I did send you the letter Orozco sent me . . . Word for word it is what Lupe Rivera [Diego's wife] learned from three different sources." And on March 31, "Lupe Rivera was like a lioness in fury because Pacheco was featured on a par with Diego in the newspapers."

is necessary to start over again and get rid of every trace of "Mexican" if one wants to have a personality of his own, because otherwise we shall be forever "Rivera's disciples."

The famous "art book" was a failure, it was rejected and I hope it will not be published, because it would make the situation even worse.[18]

Rents in N. York are high: I have an acquaintance who lives /"uptown,"/ on 198th, and he has a small apartment in a large building like those in Mexico—three little rooms, bath and kitchenette, all very small, and he pays 75 dollars including heat, with light and gas extra, but it seems that there are some for less in Brooklyn and certain outlying sections. On Sunday I'll send you the classified section of the *Times* to give you an idea. Of course I can help when you come, because I know the city very well.[19]

I wish that Juan could persuade Anita not to publish the book, for in good faith or bad it will end by ruining us, because it is just like playing into Rivera's hands. Things here are very different from what Juan thinks. That Mrs. Payne or Paine is terrible, she deceived everyone in Mexico and is apparently a very smart businesswoman.

This very day I'm going to find out about that Argos agency you mention and I'll let you know about it. I was wishing very much that Juan were here so he could see how wrong we were in Mexico about certain things. It is true that this is a very difficult environment, but there is still some hope, one can work and, even though the result is slow in coming, I have faith that it will come.

[18] Anita Brenner's *Idols behind Altars.*

[19] From my mother, March 26: "Orozco acts really well with me. He keeps his promises. He has sent me whole pages of newspapers listing rooms and apartments for rent. That is most helpful and offers as thoroughly as possible all data about the different districts."

The winter season is already so far along that there is no use to think about exhibitions now. Instead I'll have to get some work ready for next winter, toward the end of the year.

There have been some splendid exhibitions of painting. All the modern art *de Paris* has paraded through the galleries and an exhibition of old Spanish paintings has just opened at the Metropolitan Museum. There are about 15 Grecos, and the same number of Goyas, Velázquezes, Zurbaráns, etc. These are pictures lent by millionaire collectors and it is a magnificent group. The Grecos are extraordinary.

I wrote a letter to Juan in Yucatán, but he hasn't answered yet.

I send you my best wishes and I am, as always,

Yours sincerely,

J. C. OROZCO

P.S. When you write me in the future, please use this address:
 c/o Mexican Consulate General
 New York, N.Y. U.S.A.

I am going to move out of the room I am living in now and look for another.

Vale

§ 8 §

N.Y. 22 Feb. 28

Jean,

Let me know if you receive this.

Your mother wrote and I'm answering her now and sending some clippings.

CLEMENTE

Address:
c/o Mexican Consulate General
New York, N.Y.
U.S.A.

§ 9 §

23 Feb. 28

Very dear Jean:

I have just received your letter. The Art Center show—a total, absolute, and definitive failure: FACTS: the gallery is bad, just amateurs and beginners, the room dark, the director an imbecile, complete chaos, after one week there wasn't even a catalog. They shuffled the pictures, and as those by Pacheco, Ruiz, and Montenegro were the largest ones, they put them in the best places, those that were most visible. There were also Hidalgo's little wax monkeys and dressed fleas. The very few people who came just laughed and joked or felt /"disappointed."/ The serious art press, like *The Arts*, *Art News*, etc., didn't say a word, neither did the critics. When they asked Walter Pach his opinion, right there in the hall, he said that he "had not had time to see" the show. The newspapers and some /magazines/ just ridiculed it too and a number of them had some very harsh words to say (I sent a few clippings to your mother). If anyone ventured to say something favorable, it was always to rave about Pacheco. It seems only one picture was sold, I heard it was one of yours. I can tell you that the only purpose of the show is to sell trinkets of "Mexican folk art" (?), a commercial enterprise, for which our pictures have merely served as advertising posters. Pach himself assures me that the director is a scoundrel, that he is just there to earn ten thousand dollars a year. As to that Mrs. Paine, they say she is a kind of Dr. Atl in skirts,[20] involved in a thousand different

[20] Gerardo Murillo, known as Dr. Atl, a name bestowed upon himself by himself. It is a Nahuatl word meaning "water." An older man than Orozco, Atl played an important role in introducing him to the art of the greatest masters, men like Titian and Michelangelo. He also involved the not unwilling Orozco in the thick of revolutionary happenings, by persuading him to take sides with Carranza against both Zapata and Villa. Atl was a writer, a landscape painter, a labor organizer, and a well-known vulcanolo-

schemes, all half-baked and very different from one another; and there is no denying that she deceived everyone in Mexico.

I can't tell you anything about Anita because I haven't been seeing her. I had to cut off all relations with her and adopt an attitude that was perhaps less than gallant but very vigorous and necessary.

As to the "Friends" (?) I had here, I've sent them all to the devil, because they treated me with scorn and humiliated me. I am completely isolated, but happily I don't need "protectors," "guardians," /"managers,"/ "critics," "papas," "prodders," or "helpers," they are all a flock of false and self-seeking persons who only see one as an object to be exploited.

Anita wrote an article in the *World* that could easily have been signed by Diego Rivera. You will soon see how different things seem, here in New York. What you must do is use your influence with her so that she will not publish the famous "art book," because it will only help Rivera in his game and will end by ruining us. Of course, it wasn't accepted, I hear that it was rejected by a Mr. Harry Bloch; I don't know who he is.

PAINTING: Have I seen painting! An extraordinary exhibition of Spanish painting: EL GRECO, GOYA, VELÁZQUEZ, etc., pictures lent by millionaire collectors, at the Metropolitan Museum. 67 pictures, 13 of which are Grecos, how can I put into words the impression they made on me? The moderns may be "great men" or "great masters," but El Greco is a God. What can I say about Goya? I had a certain prejudice against Velázquez, but in the presence of the evidence one has to capitulate: if to paint is to put colors on a surface, only his equals can do it with the same mastery and perfection. Goya, for example, in a portrait there,

gist. *Editorial Cultura* published in 1922 his book *Artes Populares*, which made Mexican folk arts fashionable with Mexico's high-brows, hence tying Atl's name with that of Mrs. Paine. Orozco always showed the greatest respect for Atl. Totally uncharacteristic is this flip mention of his name.

"PEPE HILLO," is not the Goya of the *anecdote*, but the Goya who turns the impasto of color into a craft, a worker Goya. Here it is not a matter of "admiration," "pleasure," or "study," no, here you can only feel the humility one feels in the presence of a storm, a star, or any other spectacle of Nature.

Several days ago there was also another very important show: 24 Cézannes, half of them pictures lent by private individuals and half from Rosenberg. I went every morning for a week to study Cézanne. Perhaps very close to El Greco. Good old Matisse disappears.

An /exhibit/ of many Degas. I am not enthusiastic.

An /exhibit/ of many Giorgio de Chiricos at the Valentine Gallery, /camouflage, trick,/ extravagance, and farce, in short: very "daring" (?) but *nothing*. That Valentine Gallery belongs to Dudensing and Matisse's son, very nice fellows, you'll get to know them, their gallery is very pretty, Covarrubias is going to have another /exhibit/ there soon. They say that Chirico sold a lot.

Forain: he is really pretty bad.

LITHOGRAPHY: I am going to do it, it's easy, it doesn't have to be done on stone, there are some special plates, I already have two of them. There is a Mr. Miller who has a lithography studio here and he is the one who makes the prints for the art galleries.[21] The plates I bought (26 x 43 centimeters) cost 50 cents each, the printing of the first 12 proofs costs 10 dollars, and each additional one is 25 cents, plus the paper. It's expensive for me, but I'll see if I can manage it.

[21] George Miller, whose workshop was at 9 East Fourteenth Street. He had his presses and his stones there, and always some stone lithographers were at work. He also prepared zinc plates that one could take home. Orozco introduced me to George Miller, and I worked with him. The beauty of his black-and-white proofs was unmatched. Poorly advised by his Delphic friends, Orozco switched the next year to another, cheaper printer. The difference in quality between the Miller prints and the later ones will help future catalogers establish the sequence of Orozco's New York graphic work.

There are also many facilities for all kinds of cuts. With lino-
leum it's very easy.

Diegoff Riveritch Romanoff: Still a big threat to us. As I told
your mother when I answered her letter, the idea that we are all
his disciples is very well entrenched here. To talk about "Indians,"
"revolution," "Mexican renaissance," "folk arts," *"retablos,"* etc.,
etc., is to talk about Rivera, and tell me—what else does Anita
talk about? The "syndicate" (?)[22] and "proletariat," Max. Pacheco,
"agrarian reformists," etc., etc., all those words are synonyms of
Diegoff, and what we must do is combat by any means necessary
that "Mexicanist" con man whose Prophets are now Mrs. Paine
and Anita.

I have heard that up to now there was a very receptive attitude
toward everything Mexican as a result of the publicity that had
been given it (based on Rivera), but it all came to an end with
the Art Center show and I am happy about that because it will be
the beginning of a new era in which each person will be judged
for himself alone, and not for his *exotic-picturesque-renascentist-
Mexican-Riverian* quality.

The /Mexican fashion/ or *mode de Mexique,* whatever you
want to call it, that farce, is now passing. One proof of this is the
exhibition of Diegoff's work that was held at the so-called Wheye
or Wyhe Gallery. It is not a gallery at all, just a very small book-
store, like "Cultura" or Robredo's, a kind of Volador in miniature,
because it has a little of everything, even nicknacks.[23] And during
the winter they have continuous shows, each lasting for 3 days,
you can imagine what they are like. One of them was Diegoff's
and that was where I saw his cubist jokes for the first time, there

[22] An allusion to the Revolutionary Syndicate of Technical Workers,
Painters, and Sculptors founded in 1922, which included most of the mural-
ists. Orozco drew some of his most violent cartoons for its political organ,
El Machete.
[23] The Volador was the thieves' market of Mexico City, situated then be-
hind the main plaza, the Zócalo.

was one with a toothbrush glued to the canvas and a picture in the style of Zuloaga and watercolors in the style of Cézanne, etc.[24] Of course the press spoke very well of it and mentioned the Mexican Renaissance and the Indians and the Revolution and called him /"many-sided"/ and a /"great man."/ A Renaissance with toothbrushes! ! ! ! But I don't know that he has sold a single one, they have many portfolios with names on the backs, such as Picasso, Matisse, etc., etc. One of them says "Rivera," and now they have another with your watercolors and the "marvelous," /wonderful/ drawings by Máximo Pacheco. As you enter, you run smack into the *"muchacha parada"* and other "renaissances."[25] Weyhe is just good for selling cheap little things; they told me they sold one of your watercolors and two of my drawings. All they ask is a modest 33⅓% commission. I've taken my drawings out of there until the "Mexicanist" storm blows over.

Tell me Juan: aren't you angry about anything I've said in this letter? Are you still my friend?

Thanks for your article and I am looking forward to reading it. Write me at the new address because I plan to move, my room is so small that I can't work.

<div align="right">

Your friend,

CLEMENTE

c/o Mexican Consulate General
New York, N.Y.
U.S.A.

</div>

[24] Though Orozco was not ready to concede it, Rivera had played an acknowledged role in the cubist movement in Paris, specifically in the theoretical field. On this abstruse subject, one may quote another cubist, Gino Severini, writing in the *Mercure de France*, 1917: "As the painter Rivera, following [Henri] Poincaré, justly observed, 'A being living in a world with varied refractions instead of homogeneous ones, would be bound to conceive of a fourth dimension.'"

[25] As I remember it, the *"muchacha parada"* showed a Mexican girl with

P.S.

I am enclosing the catalog and you can see which pictures of yours were in the exhibition.

§ 10 §

N.Y. 10 Mar./28

Very dear Jean:

I have the honor to introduce Mr. Leon Underwood, a very fine person and a prominent English painter who is coming to visit our calamitous but well-loved Mexico.[26] I have told him about you and I think that you two will become very good friends. At present there is an interesting exhibition of his work at the Weyhe Gallery.

Try to give him some good information about the art of the Gran Tenochtitlán, not to mention the art of you Mayan Indians, on which you can speak with so much authority.[27]

I'll write you the latest news soon. Receive an embrace from

Your friend,

CLEMENTE

braided hair and flaring skirt standing against a small-town setting, the work of Abraham Angel, who died in 1924 at the age of nineteen.

[26] A letter of introduction, meant to be read by the bearer, its style is somewhat stiffer than usual. Leon Underwood was an English painter. He illustrated *Red Tiger*, a book of travels by Phillip Russell. In letter 11, Orozco gives a less stilted appreciation of the artist. In Chichén, we did what we could to accommodate our visitor overnight. In the thatched hut that I shared with another draftsman, Lowell Houser, we gave Underwood a hammock stretched on our "verandah." The following morning our visitor, wild eyed, swore that all night long an enormous tiger with luminous eyes had watched him from a nearby bush, as a cat does a mouse.

[27] Stilted though the note may seem, Orozco introduces here his little joke. Somewhat cynical in regard to my claim to Aztec ancestors, he suggests that I may as well be of Mayan descent.

§ 11 §

N.Y. 20 Mar. 1928

Very dear Jean: I have just received your letter and a photo—is it you? I can scarcely make out your glasses. On your ruins I see a magnificent Sun, here there is still some snow. Painting? So much that there isn't time to see it all, only what is most interesting: At Reinhardt: That picture by a French primitive that we saw together in *The Arts*, an exhibition of old masters and best of all, a small Chardin, so fine, so graceful, so beautiful that its very existence seemed like an illusion, rather like one's first illusions at 18 when he is pining for his first love. Wildenstein: French artists, as usual. The first Seurat I have seen; he must have been a simple man, with a pure heart, one feels guilty and sinful in the presence of his light-filled picture, the other pictures look dirty, even Cézanne, even Renoir; if there were a need (and there is *not*) for religious painting, it would be—Seurat—and not the ugly monkeys they put on the altars. But both religious painting and altars and religion are superfluous in this confounded world. Renoir with his young girls at their *toilette* (will they never end?), Monet with his market of cheap flowers. What idiot said that Toulouse-Lautrec was a painter?—or even a magazine illustrator? Constantin Guys annoys me. Pencil portraits by Ingres, *wonderful*, but it is the *past*, the PAST that is dead, and so be it! New drawings by Picasso: After going through galleries filled with tired and mediocre painting, a drawing by Picasso is like a glass of fresh, pure water—and how longed for!—preferable to the excesses of a lavish banquet. Titian: a great man, the living, enduring past. (By the way, don't pay any attention to the nonsense I write about painting.) Degas has begun to bore me, I don't want to see any more Degas for any reason. The Volador of New York: Weyhe: exhibitions every half hour, many portfolios with drawings, lithographs, engravings, etc., etc., by every painter who ever lived.

Georges Rouault, extraordinary aquatints, a unique self-portrait; after I saw it I began feverishly to study etching and aquatint, now I have a lot of information, copper plates, acids, etc., I visited studios and my head is filled with engraving: The first lithograph![28] it came out very well, now I have drawn two more and tomorrow I'll take them to the printer. I am delighted with the new method, a very interesting toy, it will keep me busy.

Gossip (don't tell anyone and tear up this letter): Covarrubias had a show at the Valentine and sold more than 3,000 dollars' worth, he exhibited the originals of the drawings he makes for *Vanity Fair*, each drawing was sold for 300 dollars, that is, for more than Picasso's, which only cost 250.[29] They say he doesn't like the idea of any more painters from Mexico coming here and I believe it from the way he treated me; he didn't even say, just to be polite, that he would introduce me to people or help me in some way. May God repay him! He is earning a mint of money.

[28] This passage is important to date Orozco's early graphic work. Of one lithograph he has seen a proof. Two other plates are ready to be printed. That first lithograph is *Vaudeville in Harlem*. The two others are *Requiem* and *Rear Guard*. Luis Cardoza y Aragón saw a letter to Mrs. Orozco dated April 20, 1929, in which Orozco states, "I have made only three lithographs in my life." Thus, there is a gap of months between these three prints and those that followed. The day that Orozco introduced me to George Miller he picked up the small edition—as much as he could afford—of *Requiem*, and we went directly to the Weyhe Gallery. Carl Zigrosser, then in charge of the upstairs art section, gave Orozco six dollars per copy cash. This to me seemed a fantastic sum. *Requiem* was chosen that year as one of the Fifty Best Prints of the Year. After that its price, with help from Weyhe who now owned the edition, rose to two hundred dollars per print. My first contact with the realities, or surrealities, of the New York art market.

[29] Miguel Covarrubias, too young to have taken part in the mural movement, came to New York in 1923, while still in his teens. Frank Crowninshield, editor of *Vanity Fair*, discovered his talent as a caricaturist and he became famous overnight. Besides his voluminous work for magazines, at that date Miguel already had published two portfolios of drawings: *The Prince of Wales and Other Famous Americans*, 1925, and *Negro Drawings*, 1927. Still in the future was his important work as an anthropologist and archaeologist, with which his name is now identified.

Walter Pach: I had to visit him and he told me he is writing a book that will be called: *Ananias or the False Artist*, because Ananias was a man in the Bible who gave only half of his wealth to Saint Peter and hid the other half, and the false artists of today are like Ananias, they want to be with the moderns with whom they strive for beauty, etc., but they make their underhanded deals and curry favor with the critics. And so you will understand why I said, "Oh, is it a book about D. Rivera?" He became very angry and I think he is seriously annoyed with me. In everything he says, he seems to infer: "Let us, the failures, bow down before the masters." And he intimates that Rivera is on the same level as Picasso and that the latter esteems the former highly. That he has photographs of the complete collection of frescoes and that although it is true that there are many influences, Picasso has also stolen a lot. Let us bow down before the masters! Hosanna! ! Pach was going to have an exhibition at Kraushaar this year, but it was moved ahead to next, he says I can see Kraushaar but he only handles good painters. May God repay him!

Nahui Olín: I understand that you know J. J. Crespo, a friend of mine who is in Los Angeles, he wrote me a few weeks ago, he tells me that Nahui and Santoyo arrived in triumph, stayed at the best hotel, gave interviews to the press, etc., and then absolute silence.[30]

"The Independents": 2,000,000 "paintings" or something like that, sculpture with wire, called very "daring" and "the latest thing" (50 years ago), perhaps an imitation of the "independents" of Paris. W. Pach, very interested, asked me if I had seen it—yes, indeed, Mr. Pach! Extraordinary, isn't it? Yes, indeed, Mr. Pach!

[30] Carmen Mondragón was given by Dr. Atl the Nahuatl surname of Nahui Olín of Aztec cosmological significance. Rivera portrayed her in his first mural, *Creation*. She also was a painter. Jorge Juan Crespo de la Serna, a Mexican art critic of note, was a painter in his own right. The letters that Orozco wrote him in the 1930's have been published: Luis Cardoza y Aragón, *Orozco* (Mexico City: Universidad Nacional Autónoma de México, 1959). Matías Santoyo was a caricaturist of local fame. There is a sequel to the

Leon Underwood, the English, very British painter who was mentioned in connection with the article "Mexican Rebel" in *The Arts* had a show at Weyhe of engravings and an oil painting with some people eating in a restaurant and sitting at the table, *nude*, a big middle-aged woman—and no one was upset. A nice fellow in spite of being English, I made friends with him, he came to my studio and is going or has already gone to visit Mexico accompanied by a well-known (in his own house) American writer; I gave him a letter to you because he said he was going to Chichén Itzá first. He says terrible things about the French painters, Picasso and Cézanne are pigs, Renoir a brute, Paris impossible; well, then, who is good? William Blake! The English! And he showed me a series of Blake's engravings about Dante and the *Divine Comedy*—that is . . . English . . . painting! /All right!/ Did he drop in on you in Chichén? He told me that when I am in London he will reccive me in his home, that London is very beautiful and not like New York, which is a damn hellhole. Will you really be here in August? *May God hear you and I won't say another word.* It will be a magnificent time of the year to prepare for the battle of next winter. As for me, I am acquiring very valuable experience in New York. I now have a studio in a very elegant section, Riverside, on the banks of the Hudson, one block from Columbia University; I have a private entrance and a fantastic anteroom decorated with dark red and black oilcloth, I added a skull and crossbones to finish it off, it used to be the studio of a German lady artist who went away to Europe, it is rather like a cellar, but with very good light, it has furniture, gas, a bathroom and, best of all, complete independence. Here you will find me if I have not already died of hunger by then, because I have only enough money to last for two months; after that—who knows?

"absolute silence" in my diary: "August 13. Met Nahui and Santoyo, back from Los Angeles. She plans to get in the movies."

I'll write more later.

<div align="right">CLEMENTE</div>

<div align="center">§ 12 §</div>

<div align="right">March 25 -/ 28</div>

Dear Jean:

I wrote you a long letter several days ago. Today I am sending some art /magazines/ for your entertainment. There is plenty of painting, but the Durand-Ruel show is the only one that is worth anything, Renoir in all his splendor, Cézanne the same. A picture by Gauguin that teaches me about the source of several tons of "painting" (?) at the Ministry of Education,[31] and poor Mr. Degas—next to Renoir! It baffles me!

I am enclosing a clipping that tells that the Min. of Education is going to put stands in the Alameda and that the stuff will be bought by Frances Toor and other folkloric artists.

. . . I'm not going to tell you any more "gossip" *because you've been letting it slip.*

<div align="right">Your friend,
CLEMENTE</div>

<div align="center">§ 13 §</div>

<div align="right">April 2 -/ 28</div>

Dear Jean:

Villon's painting is really beautiful; small, clear, very simple pictures, they are obviously the product of an environment that is completely unknown to me—Paris—and also I do not know why they are made like that, there must be many doctrines and much

[31] Rivera had decorated the two patios and the staircase of the Ministry of Education.

intellectualism behind them, but in spite of everything I like them and seeing them is a very pleasurable experience, without any jolts or shocks, everything soft, elegant, /nice, peaceful;/ just imagine that you encounter a little group of pretty young girls, very clean and smelling of perfume, you greet them, they smile at you and then you don't think any more about them.

I have gone back to Durand-Ruel, and there one receives the clearest and most absolute lesson in painting; it seems to be done deliberately: a *nature morte* by Cézanne and next to it another by Manet on exactly the same subject and of exactly the same size: the Cézanne is like a clenched fist, the one by Manet falls apart. The former LIVES, the latter *is dead*. A man standing painted by Cézanne. And another painted by Manet. The former is planted on the ground as solidly as a rock. The latter is falling: balanced on only one foot, *leaning on a walking stick* (irony!) and *out of place in the picture*. The second or third time one sees Renoir, he disappoints. Why?

I detest Mr. Degas more and more. How I wish I could take his works and hang them in a barber shop in the Peralvillo district! The "impressionists" are becoming more and more tiresome; they are all right in the *history* of art, but I don't know what they have to do with *Art*. AND *I* don't know what the devil I'm doing in art *Criticism*, damn it!

DON'T pay any attention to me.

<div style="text-align:right">

Your friend,
CLEMENTE

</div>

§ 14 §

<div style="text-align:right">

25 April 1928

</div>

Very dear Jean:

Since I have not heard from you, I suppose you must be angry with me.

Cartoon from *El Machete*. 1924. Collection of Jean Charlot.

The Wake. 1925. Pen and ink. Line cut originally published in the monthly *A.B.C.*, reproduced in *Mexican Folkways.* (See Letters 1 and 2.)

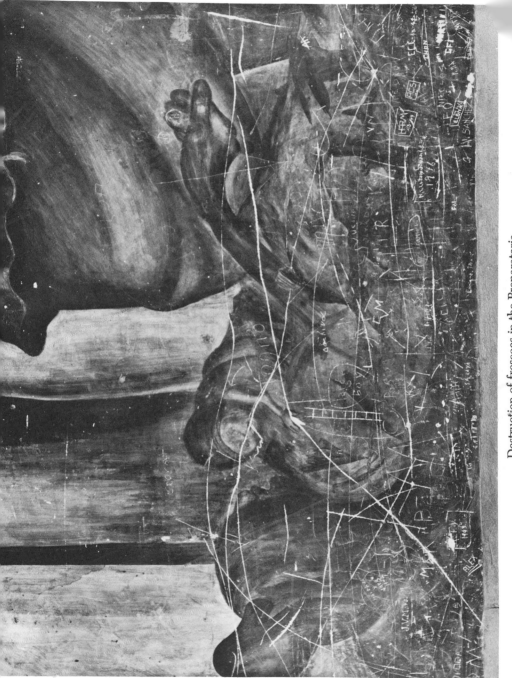

Destruction of frescoes in the Preparatoria.

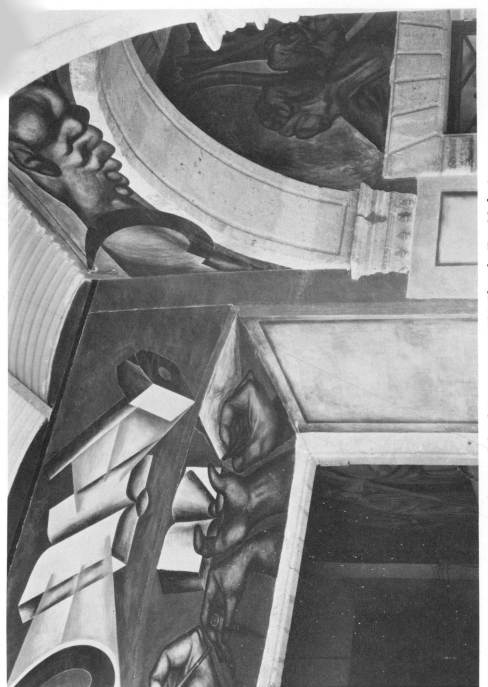

Architectural detail, Preparatoria. 1923. Photo by Tina Modotti.

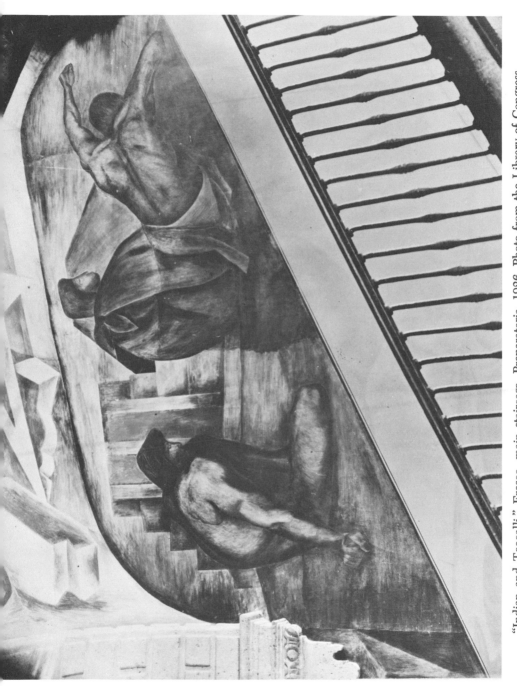

"Indian and Teocalli." Fresco, main staircase, Preparatoria. 1926. Photo from the Library of Congress.

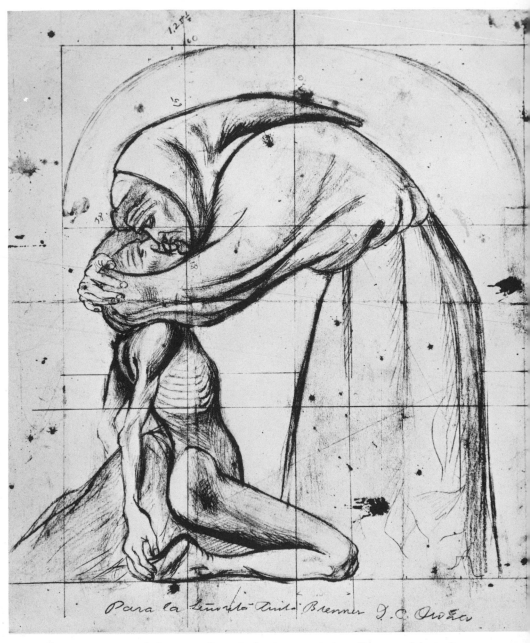

Para la Senorita Anita Brenner J. C. Orozco

"Saint Francis and the Leper." Study for fresco. 1923. Collection of Anita Brenner.

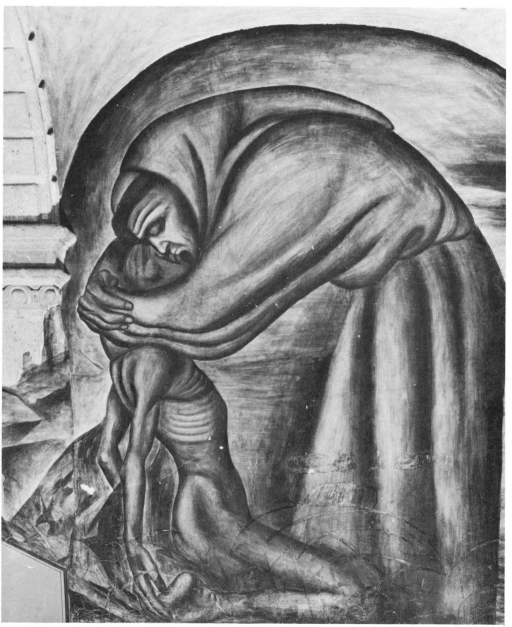

"Saint Francis and the Leper." Fresco, main staircase, Preparatoria. 1923. Photo by Tina Modotti.

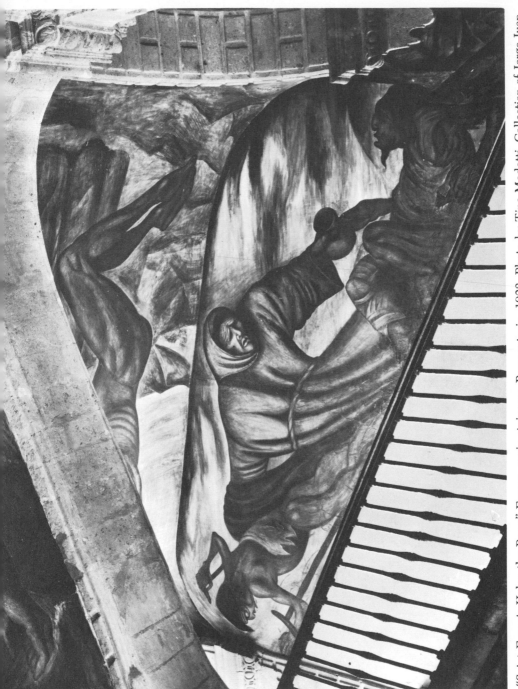

"Saint Francis Helps the Poor." Fresco, main staircase, Preparatoria. 1923. Photo by Tina Modotti. Collection of Jorge Juan Crespo.

Pre-Hispanic scene. Fresco, main staircase, Preparatoria. 1926.

"The Revolutionary Trinity." Fresco detail, Preparatoria. 1923–1924. Photo from the Library of Congress.

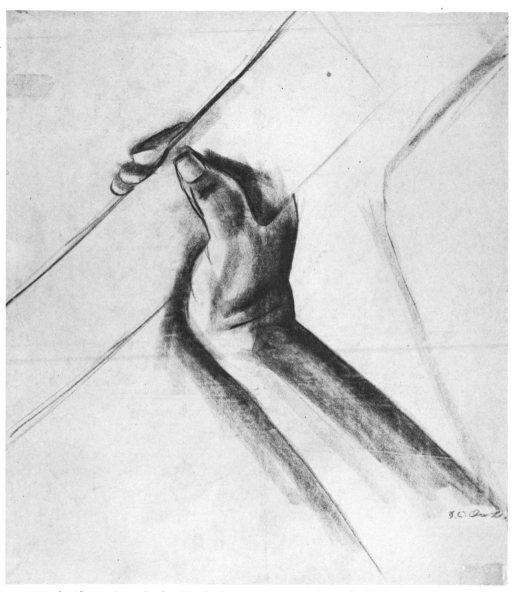

Hand. Charcoal study for "Fight between Man and Gorilla," Preparatoria. 1923.
Collection of Jean Charlot.

"The Grave Digger." Pencil study for third-floor series, Preparatoria. 1926. Collection of Jean Charlot.

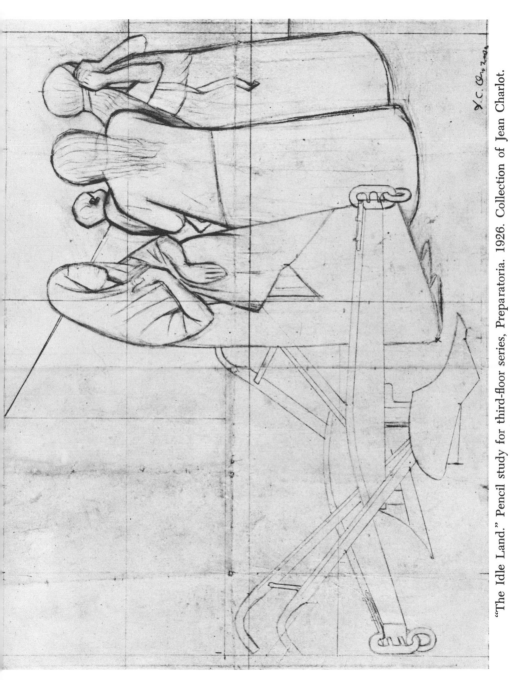

"The Idle Land." Pencil study for third-floor series, Preparatoria. 1926. Collection of Jean Charlot.

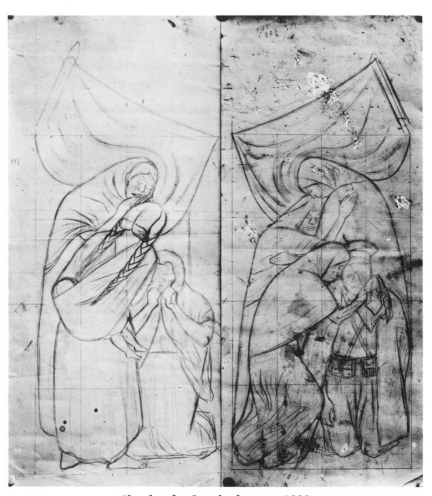

Sketches for Orizaba frescoes. 1926.

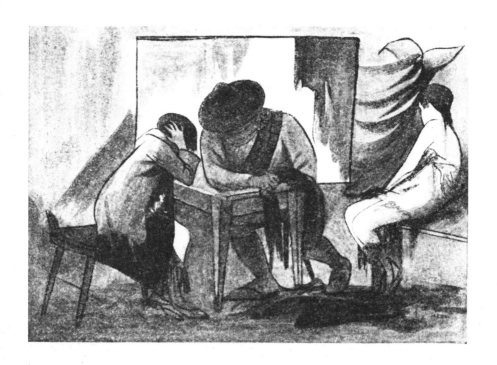

INK AND PENCIL DRAWINGS

FROM A SERIES

"MEXICO IN REVOLUTION"

BY

JOSÉ CLEMENTE OROZCO

OCTOBER 10 TO 22 1928

GALLERIES OF MARIE STERNER

9 EAST FIFTY-SEVENTH STREET · NEW YORK

Catalogue cover from Marie Sterner show, October 1928.

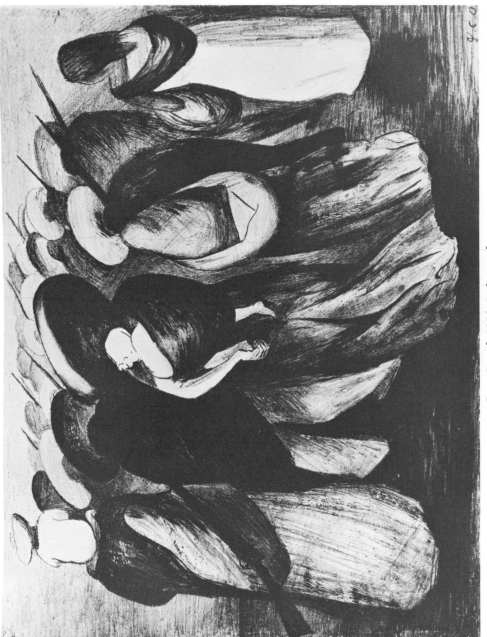

Rear Guard. 1928. Lithograph.

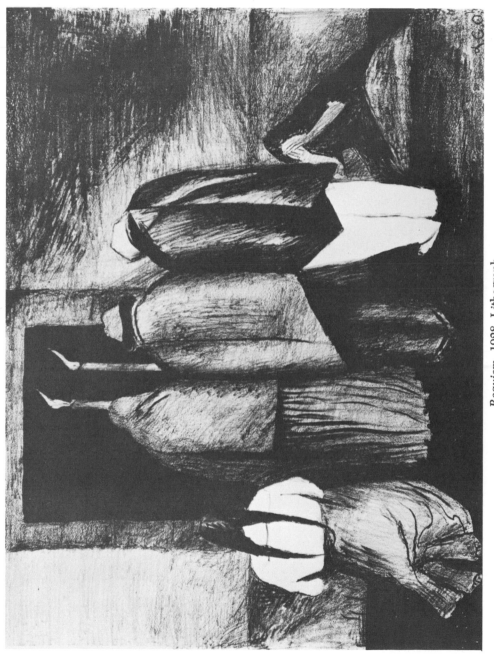

Requiem. 1928. Lithograph.

Vaudeville in Harlem. 1928. Lithograph.

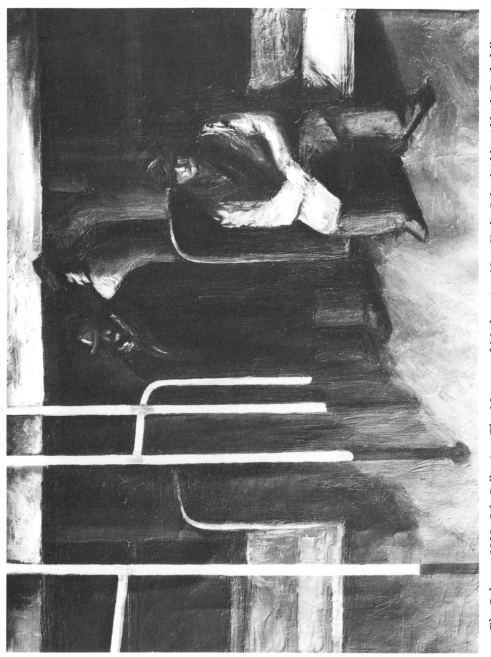

The Subway. 1928. Oil. Collection, The Museum of Modern Art, New York. Gift of Abby Aldrich Rockefeller.

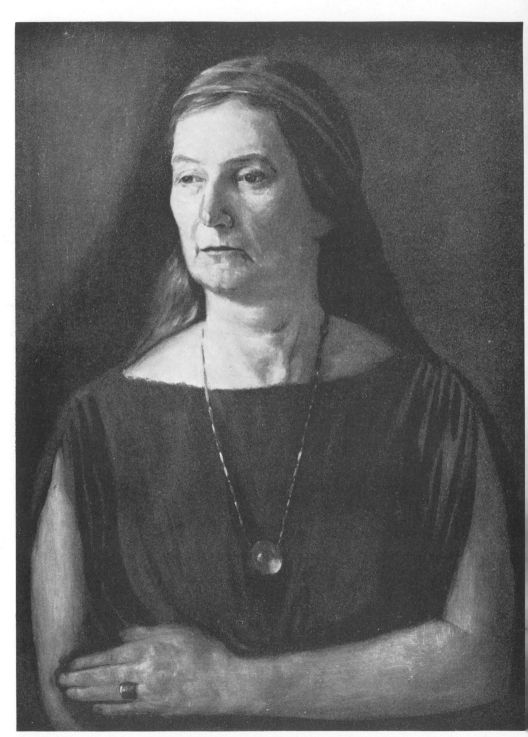

Portrait of Mme. Eva Sikelianos. 1928. Oil.

If there has unfortunately been some misunderstanding, every-
thing will be cleared up when we see each other here.

<div style="text-align: right">

Your friend,

CLEMENTE

</div>

<div style="text-align: center">

§ 15 §

</div>

<div style="text-align: right">

30 Apr. 28

</div>

Jean: your letter made me happy because I thought you were
angry. I'm sending some more /magazines/ today. I haven't had
any news from Mexico either, except from my home and family.
The Señora your mother has written me from Cuernavaca where
she seems to be enjoying the climate. I haven't had any word
about your pictures.

Now you too have heard about the "ill-fated" exhibition and
you are to blame—and so am I!—for painting the /moral deca-
dence of the French court/ of Villa de Guadalupe. Now there is
nothing left to do but start all over again and profit from experi-
ence: for the present don't give out a single painting again with-
out consulting me, I know this little game quite well now. I
haven't had anything to do with caricatures, /magazines/, or other
lesser absurdities,[32] instead I have proceeded directly to formal
painting, galleries, /dealers,/ painters, etc.; now I even have a
little circle of American friends and admirers, all of them artists.
Three nights ago they gave me a dinner party at the De la Selva
brothers' restaurant, "El Charro," and drank to the health of /the
great painter/ Orozco with very good whiskey. A Rumanian,
Iliescu, told me, although I hadn't said a word, that here everyone

[32] Before Orozco came to New York, Anita Brenner had shown to art
dealers what drawings of the Revolution she had with her. Dealers were
unanimous in stating that these were not fine art but that perhaps some
leftist magazine, such as *New Masses*, could find a use for them. Surely Anita
told Orozco of her experience.

considered me better than "the other one." When Underwood was
here we had dinner in the Village one night, he, a painter, Mau-
rice Becker, and I, and there we met another very well known
American painter, Joseph Pollet, who, when I asked what gallery
would be best for me, said that "since I had a reputation in N.
York" it would be easy for me to find one, and to my great sur-
prise he added that the Weyhe Gallery was not suitable for me
because "the other one" was there and *they would play politics
with me*. You can be sure that I didn't say anything to the one I
had just been introduced to. I'm telling you all this so you will
see clearly that only the *painters themselves, personally*, can
handle their affairs and know and see everything, and all that the
middlemen can do is ruin one. For example: I arranged for Krau-
shaar to come to my studio—he is a very important man and the
owner of one of the best galleries. I went to see him and of course
he said NO but that he would look at my pictures. A few days
later he came, I showed him the drawings, which he didn't like—
/show me the oils!/ Then he began to be interested, he liked the
painting but was horrified at the subjects and said that they were
not suitable for the American public, that I should paint some-
thing else and see him next fall when he returns from Europe. But
now I am more interested in another gallery: "New Art Circle,"
less commercial and with a freer atmosphere, although German,
because there are two galleries, one in Berlin and one here. I am
waiting to talk to the owner, who is away on a trip. This is the
gallery that handles Rouault.[33]

I think that you would be able to have immediate access to
some French or pro-French gallery such as: Durand-Ruel, Rein-
hardt, Knoedler, Dudensing, Valentine, Rosenberg, or Brummer.
The only gallery I haven't seen, *because they don't let you in*, is

[33] J. B. Neumann was that rare being, a dealer who was also an art lover.
He handled with equal respect German expressionists and Old Masters. His
gallery, the New Art Circle, was a haven for poor artists, of which I was
one. Even though he knew that I had no money to spare, he would let me
linger at will and handle to my heart's content what masterpieces passed
through his hands.

Duveen's, where the only ones who can enter are millionaires
willing to spend from 50,000 dollars up in exchange for Titians,
Rubenses, Italian primitives, and other fantastic things!

In another letter I'll tell you about the dirty tricks played by
the dealers and their panderers, the critics, to get rich at the ex-
pense of the unfortunate painters. The journal I am sending you,
Art News, is their organ and you can be sure that each thing,
every word it says, is calculated to produce a definite commercial
effect, but they don't give a damn about pure art. W. P. is one of
the panderers.

<div align="right">Your friend,</div>
<div align="right">CLEMENTE</div>

I forgot to tell you that I also had a visit from Zigrosser, the
manager of Weyhe and the great supporter, manager, and de-
fender of D. R., I invited him just to sound him out, he looked at
everything and didn't say a word, I asked if he was going to have
another exhibition of the "other one" and he said he didn't know
. . . that he hadn't had any news from Russia . . . (he is /disap-
pointed/ and completely disoriented).[34]

§ 16 §

<div align="right">June 3</div>

Very dear Jean: I haven't heard from you recently, but then I
haven't written you either. Nor have I heard anything about your
pictures. How are you? When are you returning to Mexico? Are
you still coming to Washington, as you said?

The art season here is over now, there is only the monotonous
and routine /business/ as usual.

You must not think that I have done anything new, I have limit-
ed myself to looking, observing, and meditating. Now I have to

[34] In July 1927, Rivera accepted an invitation to attend the celebrations
of the tenth anniversary of the October Revolution. Perhaps Zigrosser knew
that Rivera had plans to stay and decorate the Red Army Building. As this
plan came to naught, Rivera left Russia in May 1928.

que me queda cerca es el libro de
Anita. Eso va a acabar mal.
 Aquí ya empiezan a verle la
oreja al "Riverismo". El otro día salió
en el Herald Tribune un artículo
que se llama "Mexico's Greenvich
Village Fringe". Hablan en son de
burla de Tata Nacho, Concha Michel,
Rivera, y Maximo Pacheco y Vasconcelos.
de Rivera dicen que es el "bell-wether"
del "new Mexican art movement" o sea
el ¡cencerro! wether es borrego cas-
trado! "and might be likened to Gauquin"
"¡He is a caricaturist and satirist of
the first order"!!!!!!!!!!!!!!!! .. "
 — ¡My compliments! —
Ayer te mandé un rollo de revis-
tas y mañana te envió otros.
 No dejes de escribirme.
 Clemente.

Puedes dirigirme tu carta
Escríbeme al Consulado
por ~~~~~~~~ tengo que
Cambiarme. ___

Letter 16, June 3, 1928

think about living expenses, which are beginning to get difficult, as always. What news do you have from Mexico? I only receive news from my home and an occasional newspaper. In one of them I read that Ramos Martínez put his child prodigies to work decorating walls and that they have now painted several schools in Coyoacán and elsewhere and he is opening more open-air schools; Nonoalco, with Leal as director; Puebla, Revueltas, director; Iztacalco, Clausell, direc.; Monterrey, Cano, direc.[35]

If he decides to put one in New York I'll have to emigrate to Canada.

I sent in my resignation as "professor" (!) and they didn't want to accept it, but I became forceful.[36] The only thing that threatens me now is Anita's book. That will end badly.

Here they are already beginning to see through "Riverism." The other day there was an article in the *Herald Tribune* entitled /"Mexico's Greenwich Village Fringe."/ It refers in a joking way to Tata Nacho, Concha Michel, Rivera, and Máximo Pacheco, and

[35] On and off, Alfredo Ramos Martínez had been director of the Academy of Fine Arts since 1911, when a strike of art students synchronized with the political revolution ousted most Academy teachers. By contrast, Ramos boosted impressionism. His first open-air school, called Barbizon in homage to French landscapists, opened in 1913. Next came Coyoacán, where in 1922 I shared a studio with Fernando Leal. To get further away from academism, Ramos encouraged children to express themselves at will and drastically decentralized his open-air schools.

[36] In the archives of the Academy of Fine Arts is filed the following:

José Clemente Orozco, 316 W. 23rd St.
New York City, N.Y. U.S.A.

To the President of the National University of Mexico

The petitioner, professor of modelling in night class at the Academy of Fine Arts states: That, finding himself in this city for the purpose of opening an exhibition of his works and needing to remain for the while in foreign parts, he requests a leave of absence without pay, valid for six months; its purpose that of dedicating himself to the previously mentioned activity.

New York City, N.Y. February 1, 1928
José Clemente Orozco

Vasconcelos. It says that Rivera is the /"bellwether"/ of the /"new Mexican art movement"/—that he is the castrated ram who leads the sheep at the sound of his bell!—/"and might be likened to Gauguin." "He is a caricaturist and satirist of the first order! ! ! . . ."/

/My compliments!/

Yesterday I sent you a bundle of magazines and tomorrow I'll send some more.

Be sure to write.

<div align="right">**CLEMENTE**</div>

You can send your letters to*
431 Riverside Drive.*
Write me at the Consulate
because I have to move.

§ 17 §

<div align="right">June 8 -/ 28</div>

My dear Jean: I have just received your letter telling me that you will soon be coming to New York, and this makes me very happy.[37] As I told you several days ago, I had to move out of the other room, but I changed to an apartment here at 431 so I'll be able to take care of your trunk when it comes; don't worry about it.

Be sure to tell me the exact date of your arrival as soon as you know.

Right now I am not thinking about art or anything of the sort but about looking for work—a job—because the situation is get-

*These two lines were crossed out in the original letter.—Trans.

[37] I returned from Yucatán on June 17. From now on, Orozco's letters were received, first, in Cuernavaca, where I joined my mother, and after that in Mexico City while we were waiting for our immigration papers, ready to leave for New York.

ting critical, both here and at my home in Mexico. You know how unsuited I am for "practical life," but one has to live somehow.

I have two requests: 1. Give me Carlos Mérida's address.[38] 2. Write me at the Consulate.

Your friend,
CLEMENTE

§ 18 §

July 8

Very dear Jean:

I hope that you have received my previous letters in which I told you that I received your trunk, a package with engravings from San Francisco, Calif., and Anita received a good number of your works. She asked if I wanted to take the larger pictures, and everything is here at your disposal. I also told you that they gave me a copy of *Mexican Life* with your splendid article and that I was duly grateful for your kindness.[39] Why wasn't it published in *Forma*?[40]

I hope that you will come as soon as possible to arrange and decide a number of things, among them the damnable /"Mexican movement"/ of which Anita is the prophet and which is going to end by ruining us.

Try to rest because a terrible struggle awaits you here, as it does everyone. It is here that all your doubts, of every sort, will be dispelled, in this atmosphere of crudity, of the most sordid egoism,

[38] Guatemaltecan by birth, Carlos Mérida is a major figure among Mexican artists.

[39] The May number of this English-language monthly published a first version of my article on Orozco, published later in *Forma* in Spanish (see note 43).

[40] An excellent art magazine edited by Gabriel Fernández Ledesma, a painter and engraver of note.

of commercialism and stupidity. I think that here you'll have to change many of your opinions about people, ideas, and things.

The heat is unbearable, perhaps like the heat of your ruins.

An affectionate greeting to the Señora your mother.

<div align="right">

Your friend,

CLEMENTE

</div>

<div align="center">

§ 19 §

</div>

<div align="right">

July 20

</div>

My dear Jean:

The issue of *Forma* I received was sent by my brother; the one you sent hasn't come yet.

I understand very well the state of mind you are in, and the best thing for you to do, as I said, is to rest and forget about everything. You'll have enough to do here.

I know that boy you met in Veracruz, but I doubt what you say about the *Times.*

What you tell me about the pulque shops is very funny and seems like a good idea. I hope that the next step will be to do away with them. It's high time we were getting civilized, although then we may not be as picturesque. The greater the savagery, the "stronger the 'folk' art." (?)

All that I found out about the Shore woman is that she had a show in Los Angeles and exhibited our portraits, /"outstanding artists of Mexico City,"/ as it said in an *Art News* that I sent to you in Yucatán.[41] Did you see it?

The Paine woman is on vacation. She got $15,000 from Rocke-

[41] Henrietta Shore, a California painter, visited Mexico in 1927 and painted from life both Orozco's portrait and mine. Merle Armitage published in 1933 a monograph on her work, with my own portrait of Henrietta Shore for a frontispiece.

feller, supposedly to promote the folk art of Mexico. Decidedly, this /"Folklore"/ business is lucrative . . . for the "sharpies"—and there's still more to be gained from it, you'll see.

I wrote to the Señora your mother the day before yesterday, in answer to her letter.

Be sure to write.

<div align="right">Your friend,
CLEMENTE</div>

§ 20 §

<div align="right">July 21</div>

My dearest Jean, I have just received your last letter in which you send me the clipping about the Maroto-Rivera fracas. Also I am sending to Mexico for the first issue of *Contemporáneos* which, as Owens tells me, is being published by Torres Bodet.[42] Perhaps you may remember Owens, of the "Ulysses" group. Novo has just arrived to work as an employee at the Consulate. I just took a quick glance at the second issue, which has a very funny little article about Agustín Lazo in Paris, I'll ask Owens for it later so I can have more time to look at it. Apparently Rivera didn't like what Maroto said.

I have just written to Carlos Mérida, who is now in Mexico as

[42] A review that featured poetry, literature, and art criticism. In its first number, June 1928, appeared the article that caused what Orozco refers to as the Maroto-Rivera fracas. Gabriel García Maroto was one of the many Spaniards who took refuge in Mexico due to the political events at home. His dispassionate dissection of Rivera's art and fame made scandal in Mexican art circles. Definitely European in his point of view, Maroto could hardly enthuse at this reapparition of a truly didactic style. What may have pleased Orozco most was that Maroto denied Rivera true originality, calling his murals "a summing up of the main artistic currents that dominated Europe, from Giotto to the end of the nineteenth century."

an attaché at the Guatemalan embassy. Try to see him when you go to Mexico City.

In the letter I wrote your mother a few days ago I mentioned how happy I was with your splendidly illustrated article in *Forma* and how much I appreciated it, and that it was the ONLY one I have liked because it was done with such sincerity and profound good faith.[43] The illustrations couldn't be better, or more carefully chosen, and it is most interesting to have the paintings next to the studies from which they were made. You have already seen that the other articles are just a collection of anecdotes and ridiculous gossip, without any point whatever. And if I expressed appreciation for the one in *The Arts*, it was only out of courtesy and because you can't tell the truth to a woman.[44]

Believe me, I don't even remember what I said in my previous letters because lately I've been very worried about my economic situation. No one helps me, either here or in Mexico, and I don't know what I'm going to do.

I urge you to be sure to write.

We'll be able to talk at greater length about many things that interest us when we see each other.

Don't forget

CLEMENTE

Address your letters to me at 426 W. 22d St.

§ 21 §

July 22

Dearest Jean:

If it is not too much trouble and you can easily find the time, please bring me, along with your things, some of the drawings I have there, the ones you think suitable, because I believe some of them could be included in an exhibition that I might have here.

[43] "José Clemente Orozco: Su obra monumental," *Forma* no. 6 (June 1928).

[44] Anita Brenner, "A Mexican Rebel," *The Arts* 12, no. 4 (October 1926).

There are some little galleries where one can exhibit drawings, prints, and small paintings without too much difficulty, and it is always good to have material to exhibit on hand. At your convenience, you can go to see my wife and look at what is available. I have already told her about this.

Yesterday I wrote to tell you how much I liked and appreciated your article in *Forma*, the presentation of which I did not expect, certainly.

The weather has been very pleasant these days because it has been rainy and cloudy. I hope it continues like this.

Write.

CLEMENTE

§ 22 §

August 3

Very dear Jean:

Your idea about "tiger hunters" is very good because when you get here you'll become one of them and you'll have to contend not only with tigers but with all kinds of wild beasts, the most abominable and ferocious sorts.[45]

I don't talk about exhibitions any more for the simple reason that there aren't any. You have no idea how every bit of activity here stops in the summer, and the little that does go on is so unimportant that it doesn't matter. There are no plays, or concerts, or painting, or anything like that. Newspapers reduce their pages to the bare minimum, and business and everything else slows down. The worst thing is that the "civilized" people go to the country, to Europe, to Mexico, anywhere. By civilized I mean the cultured people and those who have money and spend it on art, in

[45] See the Foreword for a description of the actual hunt. I was working at the time on a painting on this subject, but I destroyed it. Soon after, in New York, I succeeded at a second try, in one of the first lithographs that George Miller printed for me.

any of its forms. New York is absolutely "dead" at this season, even business. The only entertainment is the movies with old films and very small audiences, all in shirt sleeves. Only those of us who are very "unfortunate" remain here, because even people with limited means go away on vacation.

I know that Anita received the *Forma* you sent, but I haven't heard anything from Pach for a long time now, perhaps he is away too, or hiding, because someone as well known as he is can't stay in N.Y. in /summer/ without appearing ridiculous.

I have NOT grown tired of the masters, I am now making a careful study of the primitives in the Metropolitan Museum, which is the only place where art can be seen at this season.

In one of my previous letters I asked if it might be possible for you to bring some of my drawings, the ones you consider least bad, but only if it isn't too much trouble and you find it convenient to do so.

DON'T fail to write.

It is important for me to know the time of your arrival in N.Y. and you must wire me this information, because there are many trains at all hours of the day and night. If you come by way of Laredo you must notify me from Saint Louis, Missouri. Not from any other place.

I am waiting to hear from you.

 CLEMENTE

§ 23 §

 August 10/28

Dearest Jean:

W. Pach wrote me a letter which reads, in part, as follows:

"But my real reason for writing is to tell you how very much I liked your paintings and drawings that were illustrated in *Forma*, which our good friend Charlot has just sent me. His article is

splendid; I congratulate you for having such an understanding critic. They are rare. But your works are truly a revelation to me. How I like *El trabajo* [Work] with that very beautiful profile of the woman on the left! Of course I have seen photographs of your frescoes before, but I feel certain that they weren't as well chosen; at least they didn't impress me as strongly as this group does. I hope that you are working to your satisfaction and not suffering too much from the heat. We are very comfortable here in a rustic and tranquil atmosphere that I really needed in order to rest after two years of uninterrupted work in N.Y. and to give me the time to write that book *Ananias or the False Artist*, which I once told you about. It is finished now and I think there may be some good in it. I speak of conditions in Mexico and of you (certainly not as one of the many sons of Ananias)."

We'll read it, naturally, to see how many bastards there are.

Since your telegram, I've had no further word from you.

What is the present status of your papers? I am waiting to hear from you.

<div align="right">CLEMENTE</div>

Paintings that must be photographed:

1. *Cortés y la Malintzin* [Cortés and Malintzin].
2. *Hombres que beben agua* [Men who drink water] and
3. *Ingenieros* [Engineers] (side of the entrance to the stairway).
4. Panel *opposite* the Franciscan embracing the Indian, on the stairs and shaped like this

(landing of the stairs)

In this last one, there should be architectural details, such as the octagonal window and the stone arches.

§ 24 §

August 16

Very dear Jean: I received your last letter and I am really sorry about the trouble with those famous documents. I don't understand the reason for those delays and I hope everything will soon be in order. A number of people have told me that some immigration quotas don't even get filled, and the French is one of them. Be sure to keep me informed about what is going on and try to control your nerves. I have been going through some very rough times too, but I have the guts to cope with it. I assure you that right now things in Mexico are infinitely more entertaining than here, because it's extremely dull at the moment. Tell me if you received a letter I sent to your former address in which I included part of a letter from Walter Pach with congratulations on the *Forma* article, which are rightfully yours. Please tell Ledesma for me that I thank him for his determination to publish my things and that I in turn congratulate him and admire him for having the patience and heroism required to bring out this magazine with conditions in Mexico so difficult.[46] Please ask him for several copies (as many as possible) of the issue in which your article appears, to give to a number of important people here whom you will meet later and who will become your friends. Don't forget, this is very necessary. I'll try to write him too. What you say about the 30-30 group is very funny, give me some more details.[47]

I sent some letters to you in Cuernavaca but don't know whether you received them, asking if you would kindly look at my drawings in Mexico (Coyoacán) and choose the ones you think

[46] Ledesma, as editor of *Forma*, was responsible for the publication.

[47] Painters who banded together and launched a magazine called *30-30*. They attracted attention by what we would now call "happenings." It is told that a live elephant suitably attired was promenaded in the streets of Mexico City to advertise the first number of the magazine.

best and then bring them when you come, if it isn't too much trouble. Please tell me too if you picked up the ones they published. Take a little trip out to Coyoacán and enjoy the greenery along the way.

I have just received a copy of *Contemporáneos* sent by Rodríguez Lozano, which contains Maroto's article on "Mastodon."

It is quite harsh and I can understand why he didn't like it, because it tears down "Bad Faith's" most cherished ambitions, one by one. Tell me: is the decoration of the Ministry finished yet? If not, when do you think it will be? That is very interesting. *Too interesting*: THE END. Tell me what comments have been made about your article, and Maroto's, and all the latest, because *one era is ending and another is commencing* for us, begun in this monstrous New York, and I hope it will be propitious for us.

Please give my very affectionate regards to the Señora your mother. I shall be waiting to hear from you.

Your friend,
CLEMENTE

§ 25 §

N.Y. Sept. 6

Very dear Jean:

I'm very surprised that you haven't found time to write me recently. What's the matter? If by any chance it's because you're very discouraged, try to smile, here they say, /"Keep smiling,"/ even though one is in the worst possible situation, about to be hanged, for example. I assure you that New York isn't exactly a bed of roses.[48]

[48] This well-known locution, Mexican in its origin, is said to have been used by the last Indian emperor, Cuauhtémoc, while the Spaniards laid him on a bed of hot coals.

Some days ago Pach wrote me again to say that Fernando Leal had written to ask if he would write something for *30-30* magazine, the organ of the modern painters of Mexico, and he wanted to know if *30-30* was better than *Forma*, because, although he couldn't write for it regularly, he did want to do an article for Mexican readers from time to time, and he particularly wanted to send the translation of the article or chapter on Mexican painting in his book *Ananias*, which will be out in October. I told him I thought that *Forma* was better,[49] because I suspected *30-30* of being just an advertisement for a well-known cigarette or beer factory: "Smoke 30-30 and you'll be happy," "30-30 beer has no equal."

Here there is still absolutely nothing that resembles art. It will be like this until October.

WRITE! Don't forget your faithful friend

 CLEMENTE

§ 26 §

Sept. 10

Very dear Jean: I received your letter and I am glad that at least you have some hope now. You must not be discouraged and besides you have to realize that since life in N. York is so busy and complicated, with so many "social" obligations, and with the days so short in winter, there is scarcely enough time to paint, and although it's true that you aren't doing it now, because you aren't in the right frame of mind, you can still do mental work and make little sketches to develop later. If you bring a collection of these, you'll see how useful they will be.

[49] Pach's article appeared in *Forma* no. 7, together with a letter from Pach to Ledesma dated September 18, mentioning Orozco's advice.

I saw Pach yesterday, he invited me to come to the place where he is spending the summer, a country estate called Amenia, about 100 kilometers north of N. York, owned by some very rich people, the Spingarns. They have a piece of sculpture from some French cathedral, magnificent, they say that it cost them 15,000 dollars. It's a very pretty place.

He read me the translation of the part of his book *Ananias* that refers to Mexico, it speaks of "Panchito," "Mariquita," Rivera, Orozco, Lindbergh, Morrow, "The Spirit of St. Louis," Obregón, Calles, the aviator Carranza and /"good will."/

He showed me the illustrations, which are photographs of the principal monstrosities "produced" by the American artists (?) who earn the most money. He thinks that they may accuse him of slander, because this is a very delicate matter here and it's not possible simply to say that a picture or an artist is bad, each day he has conferences with two lawyers, one his and the other his publisher's. Now I understand why the critics find everything wonderful and marvelous. If they really fustigate the daubs, there will be a big fuss. He's still saying that Rivera is the animator, cause, and source of Painting in Mexico and that he gave those around him their technical training. It's the same old story! I think he needs a purgative and maybe even an emetic.

A week ago I was in Washington. The ambassador knows about painting. The embassy impossible, but converted into a *cantina*— very good wines. Washington is above all the city of snobs and fakes whose money comes from mysterious sources. What statues! Three thousand of them in all sizes, colors, and flavors, they're even in the sewers, from Joan of Arc to Senator X. Final drinking party with the embassy people—hangover the next day—night festival on the eve of Saint Fortunata's day in the Italian section— like those in Mexico. There are no peanuts, but there are snails, which look almost the same, except that they are peanuts (or

snails) that move and climb little sticks.—Incorporation of the
Greek Indian into civilization.[50]—The same as in Mexico! The
same syringe: encouragement of Greek folk arts (the serapes are
exactly alike!!), dances with Greek flageolets. All this in Delphi.
Olympic games and final performance of *Prometheus*. It all has to
do with an elderly American millionaire, the wife of the poet
Sikelianos, who is sponsoring some festivals and other things in
Delphi, Greece. Miss Alma Reed, a beautiful woman, is involved
in this affair.[51] She is one of my admirers and bought one of my
tragic drawings. The other night there was a gathering at her
house and Mme Sikelianos, in Greek costume and Greek sandals,
danced a part of *Prometheus*, singing the words in Greek. Won-
derful! Claude Bragdon, of the 4th dimension and the "Tertium
Organum," an architect and Tablada's[52] brother in theosophy, was
at the soirée. He has the face of a high-class bagman. Also present
were two dozen respectable old ladies, all theosophical and Greek.

Don't be alarmed if they don't answer you from the Carnegie,
Americans are serious people in winter but in the summer they
revert to their childhood and forget about everything, they play

[50] A first allusion to the animators of the festivals in Delphi.

[51] When I first saw Alma Reed in Mexico she was engaged to the governor
of Yucatán, Felipe Carillo Puerto, a blue-eyed giant who claimed descent
from the Mayan Indian hero, Nachi Cocom. For opposing the de la Huerta
military uprising, Carillo Puerto was shot by a firing squad, together with
his three brothers and ten followers, in the Mérida cemetery, January 3,
1924. Knowing both worlds, Alma Reed could help Orozco bridge the gap
between Mexico and New York. She published the first monograph on
Orozco, *José Clemente Orozco* (New York: Delphic Studios, 1932). Her
second book about the artist, *Orozco* (New York: Oxford University Press,
1956), details her role in his rise to fame.

[52] José Juan Tablada, Mexican author who resided in New York, wrote a
weekly column for the Mexican newspaper *El Universal* titled "Nueva York
de Día y de Noche." Tablada had published in English an early apprecia-
tion of Orozco's premural work, "José Clemente Orozco, the Mexican Goya,"
International Studio 78, no. 322 (March 1924). And it is in great part thanks
to him that Orozco, up to then known and liked primarily as a cartoonist,
had been commissioned to paint walls in 1923. See my *Mexican Mural
Renaissance, 1920–1925* (New Haven: Yale University Press, 1963), pp.
223–224.

golf and go fishing, Coolidge is in Wisconsin now, fishing in a pond that was stocked with fish beforehand, and there is a diver in the pond who attaches the fish to the presidential fishhook. When he is through fishing and summer is over, he will return to the /White House/ to continue harassing the Nicaraguans. Your bosses at the Carnegie are no doubt fishing too, or playing marbles.

Don't be discouraged, and write me.

A very affectionate greeting to the Señora your mother.

CLEMENTE

§ 27 §

N. Y. Sept. 15

Very dear Jean: Excuse the trouble my wife is giving you in Mexico with regard to my drawings and photographs. If by any chance you might find it useful to work in the studio at Coyoacán despite the distance involved, you know that it is at your disposal. I already told Margarita[53] about this. As I said in my previous letter, you must bring as many works as possible, even if they are just little studies for future pictures.

I am going to tell you some things about the trip that may perhaps be useful. See if it is convenient to come by sea. Covarrubias and Tamayo came on the *Habana* and it seems to be a good ship. It costs 120 dollars from Mexico City to New York. Ask them about it. By train there are several routes, but the most popular one is by way of Laredo because it's the shortest. In Laredo there are 2 bridges, one for the train and the other for cars and pedestrians. The immigration offices, both Mexican and American, are on the latter. When the train arrives in Laredo, it continues on to the American side in a few minutes. The travelers who have absolutely no difficulty crossing the border, such as tourists, diplomats, etc., continue on the train, but when there is some problem,

[53] The artist's wife, Margarita Valladares de Orozco.

they necessarily have to go to the American office on the other
bridge. I think that you, coming as immigrants, have to do this
anyhow. Find out about it at the American consulate. But there
is no objection to your getting off at the station in Nuevo Laredo
(Mexico). You can change your money into dollars at an office of
the Banco de México there, and if the train arrives early in the
morning, they wait there until daybreak, although the taxi drivers
will invite you to go to the other bridge, which opens around 7:00
in the morning. It is about 15 or 20 blocks away. You can take a
cab. The Mexican side of the bridge is filled with bars. There you
can drink your last *good* tequila because here it's very bad, al-
though more abundant. *Don't* bring any gold coins. At the Ameri-
can office they vaccinate you and I think they will confess you
and keep your confession on file. From there you have to take a
cab to go to the other station, which is quite far away. If the
negotiations don't take too long, you can take the train that leaves
around 9:00 in the morning. If you miss it, you will have to be
bored in Laredo, Texas, until midnight. The train from Laredo to
San Antonio is very poor. In San Antonio you have to change both
train and station. There are some buses for this. DON'T go to the
Southern Pacific station, which takes you to California, but to the
Missouri-Pacific station. In Saint Louis you have to change trains
but not stations. Telegraph me from there. If you go through
Pittsburgh, notice the steel mills. When you come this way, you
arrive in N. York by way of Pennsylvania station, but if they sell
you tickets in Mexico for one of the many other ways there are
to come, you might arrive at Grand Central station, which is very
different. It's a good idea to bring along some food. They sell cof-
fee and sandwiches in the cars. Although the trains here have only
one class, and you can take any of them with the same ticket, you
have to remember the extras. Some trains don't have /"coaches"/
(seats only), but just sleeping cars, and there are other de luxe
trains in which you have to pay /"extra fare,"/ in addition to the
bed. Some that have /"coaches"/ have individual seats that can
be adjusted, exactly like barber chairs, and you can sleep quite

comfortably in them. I spent two nights that way and managed very well. If you prefer a bed, you have to buy it from San Antonio to Saint Louis and from there to N. York.

The weather is magnificent, very cool.

Greetings from

CLEMENTE

§ 28 §

Sept. 19

Dear Jean:

I received your last two letters and I thank you for the care you took with the photos, which seem very well chosen. The list I sent you was only an idea, because you naturally have to see which ones turn out the best, and besides I didn't know that you were to take a hand in it.

I'm enclosing a letter for Tina[54]—please give it to her as I don't know her address. I want to know if she would be willing to take four more negatives of the large vault and to see what arrangement we could make to sell proofs both here and in Mexico. I think this will also be to her advantage. The photographs of the murals will be very useful to us, as you will see.

Try to bring some photos of your things, especially of your panels in the second patio of the Ministry, which will serve, among many other things, as a purgative for good old Pach. I am especially interested in having one of *Los cargadores* [Burden bearers].[55] If you don't have a *good* photo, tell Tina to take one. *You will see how important the photos of our much talked-of murals are going to be.* At any rate, talk to Tina about this so that she can supply us with photos from Mexico.

I received the *30-30* you sent, and the truth is that I didn't believe stupidity had gone as far as it has, but it's very funny, send me the next issues.

[54] See Foreword, p. 18.

[55] One of my two frescoes in the second court of the Ministry of Educa-

What you must do is be patient, paint or draw, even if it's only something the size of this paper, and take the train as soon as they let you. I don't believe you'll have to wait beyond October. DON'T LET YOURSELF GET BORED because you'll regret it later, here you can't lose a single minute. *Everything looks different*, here in New York.

There are some matters I want to discuss, but it's not possible by letter.

If George Biddle, a New York painter, happens to be there, talk to him and give him my best.[56] You'll see what good times we'll have at his house in Croton-on-Hudson, an hour's journey from N.Y. A very nice fellow.

Forma with your article an enormous success.

The hot weather has ended now and the cold has begun. Very changeable temperatures.

A greeting to the Señora your mother.

<div style="text-align: right">CLEMENTE</div>

Have you seen Amelia?[57]

§ 29 §

<div style="text-align: right">Sept. 21</div>

Brother Jean:

Pach has just written to tell me that he already sent his article to Fernández Ledesma. If you see the latter, recommend it to

tion, the other being *Lavanderas* [Laundresses]. A third, *Danza de los listones* [Dance of the ribbons], had been destroyed by Rivera to make a place for one of his own.

56 The well-known painter and one of Orozco's earliest American patrons, George Biddle owned the 1928 oil *Coney Island*. He helped arrange the Philadelphia show at the Mary Collum Gallery that proved to be a turning point in Orozco's career.

57 Amelia del Río was a close friend and archaeologist. I illustrated her

him. Pach is an excellent person, and he's behaving well. He also tells me that he just wrote you at your last address, which I gave him, because he had written you at Independencia Street and the letter was returned. I am awaiting the photographs for the offensive I shall launch against the galleries next week, beginning with Kraushaar's, where I have already laid the groundwork. This is the ideal time to arrange exhibitions and, when you come, we shall immediately launch another offensive. The weather is still good in October. I'm going to tell you some very funny little stories. A few days ago, Anita and Mrs. Paine came to my studio and the latter suggested a Mexican exhibition in Toronto, Canada, but as she knows perfectly well that she can no longer count on the 30-30 group, she wants you and me to do it. I said to myself, is she going to try to sell *ollitas** and *metates** in Toronto, and does she want us to do her folkloric advertising again? You may perhaps have heard that Rockefeller gave her $15,000 "to promote Mexican folk art." Out loud I said yes to avoid getting involved in unpleasant and useless arguments. I also said that I didn't know if you would be willing, but Anita gave assurances that "one can do whatever one wishes" with your things.

About a month ago, Mrs. Paine sent word to Anita that Eastman, the Kodak camera millionaire, wanted a good portrait and that, although he had already had many made, he didn't like any of them, and perhaps I would do it, but as I had no portrait samples I made a self-portrait (just for the hell of it), very bad and Rembrandtesque, and then when Mrs. Paine came, she said the answer is still no, that Eastman has gone to Europe. Which doesn't bother me at all.

Another story (or more gossip): During the ill-fated and disas-

book of pre-Hispanic stories, *The Sun, the Moon, and a Rabbit* (New York: Sheed and Ward, 1935).

Ollitas are small earthenware pots; *metates* are curved stones used for grinding corn or cocoa.—Trans.

trous Art Center show, the director, Bement, once told me that
the Brooklyn Museum was interested in buying the picture that
was reproduced in *The Times, Soldiers and People on the March*,
which was true, but nothing came of it and Bement never seemed
to know how to tell me what had happened. And now Mrs. Paine
says that Bement told the director of the Brooklyn Museum that
the picture was painted on very poor canvas, and that this was
why they didn't buy it. But that isn't the worst of it—they ruined
my poor picture because they decided to put it in an old frame
that was smaller and they didn't hesitate *to cut it*! You can cut an
impressionist picture any way you choose, but you will ruin one
based on composition if you cut it. And for your edification I'll
tell you the latest little story: Mrs. Paine says that you and I
must make mural decorations and that she is going to suggest to
some architects' society here that we make a sample decoration
on paper for one of the halls or rooms of the building, "To see if
they dare to . . ." (!?!?!).

All I want to know—and it must be immediately and by return
mail—is how old you are as of today, 21 September, 1928, and if
your mother has weaned you yet.

Write.

CLEMENTE

§ 30 §

Sept. 25

My dear Jean:

I received the photos yesterday and liked them very much. They
came at a very good time because a few moments later I was on
my way to a party at Alma Reed's house where there was a pri-
vate showing of Orozco works, great publicity, famous people in
the N. Y. art world, writers, Greek poets, delegates to the Ar-
chaeology Congress, Frances Toor, Mendizábal, Director of the

Metropolitan Museum, Mrs. Paine, Tablada, your article in *Forma* a great success and it will be translated into several languages, published in the European press. The wife of Simmonson, director of *Creative Art*, organ of Dieguist propaganda in the United States, waved under my nose the *Creative Art* with illustrations of the distribution of public lands, and I waved *Forma* under hers. Very funny, a Greek poet was so moved by the corpses in the pictures that he embraced me, almost weeping; I managed, just in time, to avoid his kiss, the pig!: Greek wine and much gaiety.

Tell me something: Was Rouault acquainted with things Mexican, such as, for example, the saints of the churches, the scourged Christ of Holy Week, illustrated pennysheets, or pulque-shop painting?

I wrote you enclosing a letter for Tina and a request for four more negatives. Excuse the bother your twin is giving you.

CLEMENTE

§ 31 §

Oct. 2

Juan: to notify you of great successes. I don't have the time to go into details, but I'll tell you the most important part: On Oct. 10, first exhibition at one of the *best* galleries, group show with Matisse, Segonzac, Forain, and three other French artists.

In April of next year an exhibition arranged at the New York Architectural League, a collection with drawings you will bring and photos. *Ample photographic documentation.* I told Alma Reed, my beautiful and charming /"manager,"/ that I have a partner in this /business,/ Jean Charlot. Don't spread the news. Frances Toor is around here looking at everything and she'll probably go and tell it in Mexico. It would be well to deny it.

Send news, photographs.

CLEMENTE

Oct 2.

Juan, para anunciarte grandes éxitos. No tengo tiempo de entrar en detalles pero te diré lo principal: El 10 de Oct. primera exposición en una de las _mejores_ galerías, en grupo con Matisse, de Segonzac, Forain y otros tres franceses.

En Abril del año próximo exhibición arreglada en la Liga de Arquitectos de Nueva York, este con dibujos que traerás y fotos. _Amplia documentación fotográfica._ Le dije a Alma Reed, mi bella y gentil "manager" que tengo compañero en ese business, Jean Charlot. No divulgues la noticia. Aquí anda Frances Toor viéndolo todo y probablemente lo vaya a contar a México. Sería bueno desmentirlo.

Escríbeme noticias. fotografías

Clemente.

Letter 31, October 2, 1928

§ 32 §

Oct. 8

Dear Jean: Perhaps some letters have been lost because in several
of them I told you that I like the photos very much. Now I have
received your letter telling me about the ones you and Tina took
on Sunday, and I don't think you could have made a better choice
of subjects. I thank you very much and I await them impatiently.
I haven't had time to tell you, in detail, about my recent activities
but I shall do so in a few words: the exhibition at Alma Reed's
house was very informal but it had great and magnificent conse-
quences. Many, many people (some of the best) came to see it
and there were so many compliments that a Greek poet even
wrote some verses to me and recited them at a gathering of very
elegant people. That was the funny part. The serious thing was
that the exhibition of the now famous "horrors"[58] was arranged
at one of the most /"exclusive"/ galleries on 57th Street, Marie
Sterner's, along with other exhibitions of 6 French artists, Matisse
and others. This show is very good as an introduction to high
circles of painting. I've already told you that in April we can
exhibit photos of mural painting and drawings of frescoes at the
annual exhibition of the N. Y. Architectural League.

Alma Reed suggests that we send good photographs of the fres-
coes, in suitable frames, to the offices, studios, or shops of the best
architects in N. York. This seems like a very good idea because of
possibilities for the future. So you see that the photos are going
to have very many uses: publicity, exhibition, reproduction, etc.
Because of this architectural idea, I have insisted that the photo-
graphs show clearly that these are *mural decorations* and not sim-
ply pictures.

I also hope to have another exhibition of pure painting at an-
other good gallery, possibly Kraushaar, for which I have already

[58] When Orozco started the series of drawings of revolutionary subjects in
1926, Anita Brenner and I baptized them "Los horrores de la Revolución,"
as a good-humored parallel to Goya's "Los desastres de la Guerra."

laid the groundwork in such a way that it looks like a sure thing now.[59] The exhibition at "Marie Sterner" will serve, precisely, to open doors. Enclosed you will find an invitation.

I am making a portrait of Mme Sikelianos (Alma Reed lives with her), something new, with a complicated palette and treated as a mural. The model is very interesting, she is a lady of 55, golden hair and Greek costume. A very cultivated person.

Yesterday she and Alma Reed invited me to fly in an airplane at Curtiss Field. Half an hour in the air—wonderful and very exciting! You can imagine what a new experience it was for me, there were /"stunts,"/ the pilot was a good aviator, director of the camp.

See if there is any possibility of taking one or two photos that include the pretty door of the "Generalito" and the arches (with *Huelga* at one side and the so-called *Trinidad* at the other). Perhaps placing the camera in the patio about 10 or 12 feet from the corridor will produce something pretty with architecture and painting. The door that faces San Ildefonso, the large one, with the decorations above, may also turn out well.

I want to tell you again that everything you have done is excellent. Please see if it may be possible to take the arches of the patio with the painting in the background, *having the architecture as principal subject*, to show that it is a *decorated building*. The pictures themselves *aren't important*. There are already enough of them, what matters now is the other.

DON'T say anything to Tina about the "architectural" possibilities here.[60]

A greeting to the Señora your mother.

CLEMENTE

[59] The Kraushaar show never took place, but in 1929 there were one-man shows at the Art Students League in March and at the Downtown Gallery in April.

[60] Tina was also taking photographs of the murals of Diego Rivera, hence the caution.

§ 33 §

Oct. 13

Dear Jean: I have just received your letter. The negatives I am interested in, of those that Tina has, which you sent me a list of, are the following:

Soldaderas (group)
Paz (group)
Justicia (group)
Franciscan, close-up
Head of Alvarado.

Tell Tina to make the best possible prints she can of them. In previous letters I told you that I liked the photos very much, especially the 3 heads, the Indian with the Teocalli and the architectural detail. The one that did not come out well is the one of the engineers, which I think should be done over again. I suppose Margarita already told you that I want a few more, not only the ones you said you took on Sunday, but others of the old things and with architecture. See what results you can get from the door of the Generalito with the arches (*Trinidad revolucionaria* on one side and *Huelga* on the other). I also want a good detail of the head of *La madre* and the Boy, another with architecture of the door facing San Ildefonso, the one with the grating, with the decoration of the upper part and the vault. Another with the decoration between the two doors at the entrance. A picture can also be taken of the whole wall, a short distance from the arches, from the patio, like this:

con arquitectura de la puerta que
dá a San Ildefonso, la de la re-
ja, con la decoración de arriba
y de la bóveda. Otro de la decora-
ción que está entre las dos puertas
de la portería. Además se puede
sacar algún conjunto de todo el
muro tomándolo a corta dis-
tancia de la arquería, desde el
patio así:

(cámara)
(Cámara)

esto creo puede salir muy intere-
sante. Dile a Tina especto preciso
de las amplificaciones.
 Por aquí anda F. Toor, viéndolo
todo. Hace tres días vino a mi estudio
y lo primero que hizo fué registrar
los rincones. Además hizo este chiste
cuentecito: Sabes que en casa de Alma
Reed hice una pequeña exhibición con
mis obras, con un éxito tal que ya te
contaré. Toor fué a dar ahí y viendo

Letter 33, October 13, 1928

I think it may turn out to be very interesting. Tell Tina I am waiting for the prices of the enlargements. F. Toor is in the neighborhood, snooping around. Three days ago she came to my studio and the first thing she did was to search every corner. She also did this little maneuver (gossip): You know I had a little showing of my works at Alma Reed's house, with tremendous success. Toor dropped over there and, seeing how well liked I am at that house, suggested to Alma Reed the possibility of giving a lecture on Diego Rivera. It seems that one can't have any peace even at a distance of 3,000 kilometers!

Alma asked Anita if she would agree to it, and she said that it wasn't advisable. I told Anita I was afraid that Toor would tell about our exhibition at the Architectural League and then Diego would want to be in on it, but she says we will not let this happen. For the present I don't think Toor knows about it.

You say that you're going to leave your things at Weyhe, I say that *the first thing you must do is take your things out of there.*

<div align="right">CLEMENTE</div>

<div align="center">§ 34 §</div>

TELÉGRAFOS NACIONALES
55 NEW YORK VIA MÉXICO D. F. 12 13 OCT. 48/70
MRS. MARGARITA DE OROZCO
AVENIDA HIDALGO 2

TELL JEAN TAKE AS MANY PHOTOGRAPHS AS NECESSARY NO MATTER HOW MANY ASK TINA IF SHE IS WILLING TO GO ORIZABA[61] AND HOW

[61] In 1926, Orozco had painted frescoes in Orizaba, where in 1914 Carranza and his followers, who included the artist, had encamped while on their way to Veracruz. Though the building itself, the Industrial School, is hardly more imposing than an oversized Quonset hut, the frescoes are important as being the first to treat visually, rather than symbolically, Orozco's

MUCH WANTS FOR THE TRIP TELL ESCAMILLA MAKE TWELVE COPIES
FOR TWENTY INCLUDING SIX FROM THE OLD CHRIST HEAD SENDING
TWENTY DOLLARS MORE TODAY MAIL

 CLEMENTE

9.10

§ 35 §

Oct. 15/28

Very dear Jean:

I received your letters. In the next to the last one you tell me
about the photographs you took the Sunday before and I think
they are very well chosen. I believe there really is enough material
now. On Saturday I received a package with the copies of five
negatives, which *I like very much*, most especially the one of the
mezzanine with the devils and the "liberty." The one of Cortés is
remarkable, I had already given up hope of having a photo of the
vault. I am also very impressed by the one of *Alvarado*, something
very different as a photo. Tell Tina that I congratulate her and
naturally you too, as director of the project. As soon as the photos
arrive, they are immediately put to use, because I give them to
Alma Reed for publicity. I haven't written you very much for two
reasons, first because I've had almost no free time, and second
because I thought you would be coming soon. What is the latest
on your trip? I also received your two little pictures with the
loving doves.[62] You can keep on sending as much as you wish. In
your last letter, the one I just received, you speak of the photo-

memories of the Revolution. Specifically, the two upright panels that frame
the door, "weeping women" and "adieu to the soldier," prefigure in another
medium and on another scale the series of drawings of the Revolution.

[62] Two of a series of small paintings, 14" x 11", in a bucolic mood. One is
the picture of loving doves, the other a beribboned basket filled with grapes,
grape leaves, and a Valentine heart!

graph *Ingenieros*. I found it only slightly clear in comparison with the other one from the other side, because I wanted to put them together. With regard to what you say about my writings that you found, I don't know which ones they are or what nonsense they contain, but I don't think they should be published. If you want to give some of the new photographs to *Contemporáneos*, I think it's a very good idea, some publicity is really necessary now. Choose the best ones and give them to that review and any others.

As to the Weyhe Gallery, it's really not bad for small things but they're rather shameless, not only do they charge 33% commission on what they sell, which is excessive, but it seems they also "make off" with the works when you aren't looking. You're mistaken if you think that first-class galleries won't take your *current* things. On the contrary, I think you'll be very well received at the French galleries which are the first-class ones, such as Durand-Ruel, Reinhardt, Valentine, and Rosenberg and others. As to the *successes*, they add up to the fact that I am working *in a positive way*, that is, on painting I like, and which brings me in contact with people who *really count*. I already told you in my previous letter that I am painting a portrait that, up to now, has gone well because I like it and so does the person I am painting.[63]

I sold one of the pictures that came from Mexico, the one of the white house, cheap enough, certainly, but on very favorable terms in view of the friendships I am making. The exhibition at the Marie Sterner Gallery has been an artistic success, and the gallery owner herself suggested the idea of sending the collection of drawings to Paris, which was agreed to, of course. They will be taken by Mme Sikelianos, the same lady whose portrait I am painting and who has very good connections in Europe, the best magazines in Paris and so on. Among them, *Cahiers d'Art*. Mrs. Sterner likes the drawings exceptionally well, she says that the subjects are not the important thing, but rather the plastic quality.

[63] The portrait of Mrs. Eva Sikelianos.

They had to put Forain and the others in another room because
of the *explosive* quality of the Mexican things.

Turning to *gossip,* I'll tell you: that Frances Toor wanted to
give a lecture on the *Folkloric Leader* at Alma Reed's house, but
the latter did not permit it and arranged instead for a students'
club, which Frances filled with *ollitas, cazuelas,* and *petates**
and then spoke about the Great Folkloric Leader to her heart's
content. Another very funny bit of gossip is this: that Mrs. Paine
wanted to invite ALL the mural painters of Mexico to an exhibi-
tion at the Architects Center of New York (another Art Center!),
but Alma Reed *stopped her cold!*

In short, there are so many interesting little tidbits that I could
go on and on. The best thing is for you to come and take part in
the razzle-dazzle. When do you plan to arrive?

An embrace from

CLEMENTE

I forgot to say that I sent telegrams asking for photos with archi-
tecture, that is, in which there is 90% architecture and only 10%
painting, because an architect can't be interested in monkeys
except as part of the building. I repeat that I like *all* the photos
very much and I approve them. I give you my most sincere thanks
for the trouble you have taken. With regard to Escamilla's photos,
I think that this dozen will be enough and that we won't need
any more, since Tina took so many good ones. I said in a telegram
that you should ask her how much she wanted for making a trip
to Orizaba. If it's not too much, perhaps it would be possible to
pay her to go and take some photos. I await news, the photos, and
the delightful presence of you and your mother in this city, where
the Zeppelin has just arrived, judging from the boat whistles and
the many airplanes flying over the skyscrapers.

**Ollitas* and *cazuelas* are earthenware cooking utensils; *petates* are rush
or reed mats.—Trans.

§ 36 §

Feb. 19 [1929]

Dear Jean:

I hadn't written you for two reasons, first because I thought you didn't want to speak to me again and I was waiting to hear from you,[64] and second because of the amount of work and the few hours in the day.

Some ladies from Phila. invited me to send an exhibition of Mexican pictures. A great success—a nice gallery, they don't charge any commission! Last Wednesday Alma and I went and there was a big reception, attended by the best society in Phila., G. Biddle gave a lecture on Mexican painting, fresco, and my biography. He had a hangover that had been going on for several days and you can imagine what he said, they introduced me, I said thank you, and there was a round of applause, that evening a big dinner at the home of Biddle's brother, the drinking continued and I came back. Everything is there including drawings and photos.

A gentleman offered to get us permission to visit the private collections in Phila., which are among the most important, such as Widener and Johnson (?).

We plan to go and you'll be able to see them, too. That gallery is a good one for you to exhibit in.

On March 26, a show at the Downtown Gallery with pictures of N. York, *which I haven't painted yet.* In April, a show at the

[64] Many things had happened between this letter and those that precede it. Mother and I had reached New York in October. Mother died in January. I received this last letter in Washington, where I was working on the proofs of our archaeological report, *The Temple of the Warriors at Chichen Itza, Yucatan,* by Earl H. Morris, Jean Charlot, and Ann Axtell Morris, 2 vols. (Washington, D.C.: Carnegie Institution of Washington, 1931).

Art Students League, with everything, and at the Architectural League, a mural painting *that I haven't painted yet.*

The drawings will be exhibited in Paris at the "Fermé la Nuit" Gallery starting on Feb. 24. Are you acquainted with it?

The lithograph *Requiem* was selected as one of the "50 prints of the year."

Enrique Murguía, a lawyer at the Mexican embassy, was here. If you don't know him I'll send you a letter of introduction, he comes from Mexico City, a nice fellow, young, a tippler, an ex-Dieguist, translator of Azuela's *Los de abajo* [The underdogs] into English.

Diego will do the illustrations and I the jacket and the hat, Brentano will publish it.[65]

I am sending you some clippings from the *Public Ledger.*

Tell Mr. Phillips to invite you to go to Philadelphia, there are a number of awful new little folkloric pictures that I dashed off quickly at the last minute.

"Folkways" will publish Posada and recognizes you as the father of the child.[66]

Under separate cover I am sending you my last remaining lithograph, only 2 have been sold and the rest have been beautiful Christmas and New Year's presents, with a calendar attached.

Write.

An embrace from

 CLEMENTE

G. Biddle made a big portrait of me in which I look like Lincoln.

[65] When published, *The Underdogs* was illustrated by Orozco alone.

[66] Not a reference to Frances Toor's monograph on Posada, which was published in 1930. This can refer only to a special number of *Mexican Folkways* 4, no. 3 (July–September 1928), entirely dedicated to Posada. The Spanish turn of phrase strongly suggests a foundling anonymously left in a basket at the door of potential foster parents, and of a suspicion as to who the father may be.

Three Unpublished Writings

§ 1 §

[Note: Orozco's manuscript (1923) describing his plan for the decoration just begun at the National Preparatory School.]

Decoration of the north wall of the courtyards "Colegio Grande" and "Pasantes" of the National Preparatory School.

General Theme:
The gifts that man receives from Nature.

Composed of seven subordinate themes, as follows:

1) Decoration of the door of the hall called "El Generalito" and the left side of the corridor: *Virginity*: physical integrity and spiritual integrity. Cool tones, with horizontal and vertical lines predominating; tranquillity, calm.

Secondary Composition: *Adolescence.*

2) Decoration of central area: *Youth*: allegory of the Sun and a group of students. Very warm tones; lines of movement; large masses very dynamic and ascendant.

3) Decoration of the main door and fragment of left wall: *Grace.* Warm tones. Feminine predominant.

4) Decoration of both sides of the Pasillo: *Beauty.* Warm tones. Masculine predominant.

5) Decoration of the library door: *Intelligence.* Cool and deep tones.

6) Decoration of the central area ("Pasantes"): *Genius*. Very warm tones. Lines of movement ascending and very dynamic.

7) Decoration of right side of wall: *Force*. Warm tones. Large dynamic masses. Predominance of horizontal and vertical lines.

The decoration has been planned with the same modules and rhythms that characterize the architecture of the building in order to assure complete solidarity between the two.

The method used is classic *fresco*. Work begun on July 7, 1923.

§ 2 §

[NOTE: Apologia (1923) for his early frescoes at the Preparatória, which showed, according to critics, influences from the Italian Renaissance.]

In 1916 there was an exhibition of the works that represented my technical progress and my aesthetic ideas up to that time. The latter have not changed in the slightest.

There were then in Mexico only two tendencies in painting: On the one hand, there was a small group bent on exhuming from the Archaeology Museum the decorative motifs of the magnificent art works of the indigenous antiquity, endeavoring to give them all kinds of uses and applications. On the other, there was another group devoted to impressionism and interested only in the skin or the husk of things and even the air that stood between these things and the viewer, but never in things themselves in their intrinsic nature and their density.

This being the artistic atmosphere, the exhibition of which I speak was completely misunderstood by the people, who were unaware of the new tendency represented by the works exhibited, which were called "caricatures," and, as usual, the people focused their attention only on the theme of the works and even on the

author's private life, overlooking the technique employed and the aesthetics of the exhibition.

The archaeological style of seven years ago was replaced by another similar one, which is the prevailing style at present. It consists in attributing to the pure indigene, now in a state of complete degeneration and in the process of disappearing, or pretending to attribute to him, the beautiful objects of the minor folk arts that are the natural product of the creole and the mestizo of the rural areas, and imposing on the creole and the mestizo of the cities an aesthetics that he neither feels nor can falsify by suppressing and ignoring his own aesthetic faculties. In reality, this conduct is extraordinarily humiliating and will lead to a clash whose results will be seen in the near future. In some ways, this humiliation is beneficial, because it has served as a reagent to make the humble classes become aware of their powers, shake off their inertia, and awaken.

Painting in its higher forms and painting as a minor folk art differ essentially in this: The former has invariable universal traditions from which no one can separate himself for any reason, in any country, and in any epoch. The latter has purely local traditions that vary according to the life, the changes, agitations, and convulsions of each people, each race, each nationality, each social class, and even each family or tribe.

To confuse the one with the other is a serious error, to apply to the one the laws that govern the other is a regrettable mistake because it denaturalizes it and disorients and confuses the collectivity, causing a delay in its aesthetic development.

That is why one is justified in applying what is understood by "nationalism" to the minor folk arts. But to try to apply it to great painting, to mural decoration for example, is an inexcusable blunder. Each race will be able to make, and will have to make, its intellectual and emotional contribution to that universal tradition

but will *never* be able to impose on it the local and transitory
modalities of the minor arts.

Personally, I detest representing in my works the odious and
degenerate type of the common people that is generally taken as
a "picturesque" subject to please the tourist or profit at his ex-
pense. We are chiefly responsible for having permitted the crea-
tion and fostering of the idea that the ridiculous *"charro"* and the
vapid *"china poblana"* represent so-called Mexicanism, and I
deeply regret that the no less ridiculous *"jarabe tapatío"* has be-
come popular among the classes who call themselves cultured and
educated. The sight of a *"charro"* or *"china"* and the horrendous
notes of the *"jarabe"* are inevitably associated with the memory
of the nauseating "Teatro Mexicano," all of which form what are
called "our things." Whose things? Why do the tritest and most
ridiculous attributes of one social class have to belong to a whole
country?

True nationalism must not consist in this or that theatrical cos-
tume or even in this or that popular song of more than doubtful
merit, but in our scientific, industrial, or artistic contribution to
human civilization, and the painter who works in the Italian tradi-
tion of the fifteenth and sixteenth centuries, for example, is more
of a "nationalist" than the one who goes crazy over the nationalis-
tic pots and pans that are very suitable for decorating kitchens
but not drawing rooms, and even less libraries or laboratories.

These ideas induced me to abjure, once and for all, the painting
of *huaraches* and dirty cotton pants, and naturally I wish with all
my heart that those who use them will discard them and become
civilized, but I do not glorify them, just as one does not glorify
illiteracy, pulque, or the heaps of trash that "adorn" our streets.

All aesthetics, of whatever kind, are a movement forward and
not backward. In my 1916 exhibition and in all of my serious
works there is not a single *huarache* or a single *sombrero*; the only
theme is Humanity and the only tendency is Emotion to the maxi-
mum, and for this I have utilized the REAL AND INTEGRAL repre-

sentation of bodies, in themselves and in their relations to one another.

The real work of art, like a cloud or a tree, has absolutely nothing to do with morality or immorality, with good or evil, with wisdom or ignorance, or with virtue or vice. A mountain that springs up has nothing of that, and thus must plastic or musical or literary expression spring forth, like anything that is born of the impulse of natural forces and in accordance with their laws. A painting should not be a commentary but the fact itself; not a reflection but light itself; not an interpretation but the thing to be interpreted. It should not connote any theory or be an anecdote, story, or history of any kind. It should not contain opinions about religious, political, or social matters: absolutely nothing but the plastic fact as a particular, concrete, and rigorously precise case. It must not arouse in the viewer any pity or admiration for the objects, animals, or persons of the theme. The only emotion it must generate and transmit must be that which is derived from the purely plastic, geometric, coldly geometric phenomenon, organized by a scientific technique. Everything that is not purely and exclusively the plastic, geometric language, subjected to the inescapable laws of mechanics, expressible by an equation, is a subterfuge to conceal impotence, is literature, politics, philosophy, what you will, but not painting, and when an art loses its purity and is denaturalized, it degenerates, becomes abominable, and finally disappears.

§ 3 §

[NOTE: Probably written for *La Falange* (1923), but it remained unpublished, given the short life of this literary journal.]

Triumph.
Everyone triumphs or can triumph because there is always an

audience that applauds or acclaims every talent, and every imbecile, and every scoundrel.
The only ones who fail are those who do not know how to find their audience, or cannot.

Verses.
Some poems have very good spelling and a magnificent polish but are not worth a peanut. Some paintings boast the golden proportion and that famous cubist technique. They are not worth a peanut either.

Painting *that is not understood* is pseudo-cubist painting, that is, painting done with so-called scientific *formulas*, imported from Paris. Such "painting" is not understood by anyone, not even the one who does it.

Art is, above all, GRACE. Where there is no GRACE there is no Art. GRACE is not achieved by so-called cubist formulas.

As fishermen reap much gain from troubled waters, so too *hack painters* derive great profit from confusion.

Be wary of painting that needs explanations in order to be "understood." What would you think if, while you were enjoying some good music, an erudite musicologist started to give an "explanatory" lecture?

There are also SCHOLARS of painting: they know so MUCH about it that through their works pass the paintings of all the others . . . except their own!

Painting for the People? But the People do their own painting: they don't need anyone to do it for them.

Painting is not *heard, it is seen* and in order *to see it* one merely has *to have eyes*. Pay no attention to what others say: judge for yourself with YOUR OWN EYES.

It is a lie that "one has to be a connoisseur" in order to understand and feel a painting; the roughest and most ignorant man can be attracted and subjugated by beauty, wherever it may be found. It would be a fine state of affairs if we had to be "connoisseurs" of the art of cooking in order to be able to enjoy a good meal!

INDEX

OC